HARRY STYLES
and the clothes he wears

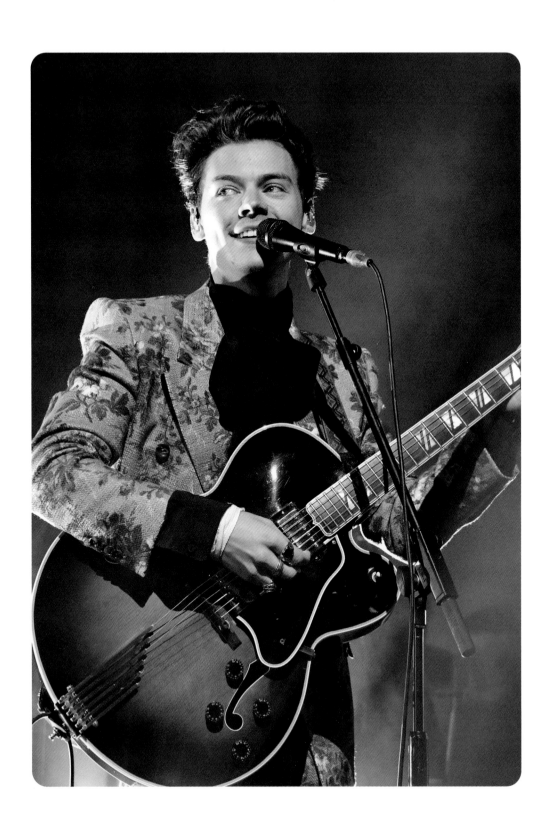

HARRY STYLES
and the clothes he wears

Terry Newman

ACC ART BOOKS

Introduction

In a digital media world where the slightest metamorphosis is keenly microscoped, fashion statements are often fuel for frenzied judgement-calls. It's easy to make a quick headline splash if you're a global superstar, but keeping the attention of your fans can be a byzantine challenge. In a world where style-statements are often monied propositions, it's difficult to tread a credible path – especially when you first appeared on *The X Factor* in 2010, aged 16, and have grown up in the public domain with every stylist and cool-hunting brand at your disposal. A personal look is paradoxically hard to hone when the finery of every couture house is within reach.

Stepping bravely into the cyclone of the 21st-century fashion-party, Harry Styles is more than weathering the storm. He is equally liable to break the internet while wearing a $7.99 frog-eyed yellow bucket hat (as he did in February 2021, post-shoot of Olivia Wilde's film, *Don't Worry Darling*), or a pair of black fishnet tights (while fronting cult magazine *The Beauty Papers* in March 2021). Hazza's sparkle has no boundaries. Even American *Vogue* featured him, their first 'femboy', on the December 2020 cover, wearing a frilled Gucci gown and a tux jacket. The paths of Gucci and Styles converged in 2014 and a formidable fashion team was born. Designer

Alessandro Michele saw Harry as 'a young Greek god with the attitude of James Dean and a little bit of Mick Jagger', and Styles repaid the compliment by wearing one of Michele's white floral suits to The American Music Awards in 2015, while he was still with One Direction. This was the start of something special, and for the 2017 leg of Styles' first solo tour, Styles signed up to exclusively wear custom-made Gucci stage outfits.

Study the heart of Styles' wardrobe, both onstage and off, and find yourself immersed in a fashion history lesson that pulls references from some of the boldest narratives in rock-and-roll. Causes tend to matter to those who look cool, and iconoclastic clothing is often used by celebs to show solidarity with society's most alienated communities. Like Styles, Kurt Cobain challenged heteronormative stereotypes through sartorial choices; his wardrobe staples included a Peter Pan-collared minidress and '50s retro frocks, and he wore a floral dress and nail varnish on the cover of UK trend-bible, *The Face* magazine, in 1993. The Nirvana frontman and father of Grunge was also a dedicated campaigner against homophobia, playing a benefit concert in opposition of Measure 9, an Oregon initiative to prevent the government from portraying queer identities in a positive light. Cobain spoke out

'I think there's so much masculinity in being vulnerable and allowing yourself to be feminine, and I'm very comfortable with that. Growing up, you don't even know what those things mean. You have this idea of what being masculine is and, as you grow up and experience more of the world, you become more comfortable with who you are. Today it's easier to embrace masculinity in so many different things. I definitely find – through music, writing, talking with friends and being open – that some of the times when I feel most confident are when I'm allowing myself to be vulnerable. It's something that I definitely try and do. '

Harry Styles, *i–D* magazine, VICE, 2019

about issues close to his heart in the folio of the *Incesticide* album, 1992: 'If any of you, in any way, hate homosexuals, people of a different colour or women, please do this one favour for us – leave us the fuck alone. Don't come to our shows and don't buy our records.' Cobain and Styles also shared a fondness for feather boas, with Styles famously flaunting two at the BRIT Awards in 2020. The 1970s glam-rock hero Marc Bolan was another devotee of the boa. In fact, Bolan's signature style – combining satin, glitter, velvet, scarves and flared trousers – is much mirrored in Styles' own red-carpet wear.

Styles' wardrobe mood-board spans decades, looking to Prince's rule in the '80s as well as the reign of Little Richard in the '50s – two electrifying personalities whose work revolutionised the world of music and proved that looking and sounding different was marvellous. Their coupling of high heels and suits seems a simple enough statement nowadays, but when Styles busts out elevated footwear on Insta, the world registers its approval, and the memory of rock and roll lives on. Styles is a post-modern mix of influences, following in the footsteps of many musical-muses, from Elvis with his pink '50s suit, Hawaiian shirts and bluff-pocket tops, to the skinny-legged showmanship style of The New York Dolls. Where will Harry's imagination travel next for outfit inspiration? We don't know, but it's always fun to witness.

The most prominent member in Styles' wardrobe of designer labels is Gucci – a platform of familiar high-fashion looks. In a short film series shot by Gus van Sant that profiled Gucci's spring-summer 2021 collection, Styles teams cut-off denim shorts with loafers, ankle socks and a pink varsity T-shirt. In the tableau titled 'At the Post-Office,' he looks rather like a character from a Wes Anderson movie – chicly unfashionable; an outsider, yet interesting.

Perhaps Styles' greatest gift to fashion is that he picks pieces off the catwalk (or the filmed collection, during the pandemic) and wears them out in the 'real' world for all to admire. He wears these pieces at premier profile events. He wears them on multi-date tours around the world, and on the cover of the biggest selling fashion magazines. And, of course, any photographs are shared billions of times online. His Midas touch has helped to communicate the ideology of fashion designers like Alessandro Michele for Gucci, who campaigns for gender fluidity and inclusivity in his collections.

As well as helping to sell clothes, Styles sells stories. In 2018, he designed a Pride T-shirt emblazoned with his well-known slogan, 'Treat people with kindness'. The proceeds went to GLSEN, a US charity for LGBTQ+ students that crusades, amongst other things, against bullying and harassment in schools. Additionally, on the Treat People With Kindness Tour, Styles raised $1.2 million for over 62 other specialist charities based in the cities and countries where he played, benefiting trusts dedicated to ameliorating child

poverty, helping refugees, and supporting those with cancer, amongst other causes. Styles has made the leap from popstar to personality by caring not just about what he wears, but also about the very real issues in the world.

It's quite a feat to become a global role model in your twenties. Styles shows us that it's okay to have fun, to be who you are and to play around with 'norms', and his confidence is catching. Michele swooped on Styles again for the 100-year anniversary year of Gucci's revitalisation of the 'Beloved' classic handbag collection, including the 1955 'Horse-Bit' and the 1961 'Jackie'. The campaign, shot by edgy image-maker Harmony Korine, shows Styles wearing a Starsky & Hutch Huggy-Bear faux-fur coat over a spangled Seventies-inspired shirt. The Gucci-Hazza formula has worked well; Michele and Styles co-hosted the 'Notes on Camp' New York Met Gala in 2019, and Styles has previously appeared in five other Gucci advertisements to date, including one for the Mémoire d'une Odeur fragrance.

However, the strongest testimony to Styles' self-assurance is his support of young designers. Harris Reed's hooped crinoline skirt with tulle and pink satin garlands, which was worn by Styles for one of the 2020 *Vogue* shoot images, is a conspicuous example. Styles first noticed this up-and-coming designer in 2017, when he was still studying at London's most famous art school, Central Saint Martins. Styles quickly commissioned a series of outfits, which he went on to wear on the second leg of his debut solo tour in 2018, alongside clothes by illustrious designers including Givenchy, Raf Simons and Alexander McQueen. Styles, his stylist and creative-collaborator Harry Lambert and the fashion maestro Reed brainstormed a positive power-ball of Victoriana-meets-Flamenco-meets-Jimi-Hendrix-wear for Harry to dance around in on the subsequent 56 show dates, which took Harry to the biggest stadiums he has ever played. At these gigs, Reed's outfits were the ones that made the headlines. Reed made Harry up like Mick Jagger when he wore Mr Fish's white dress at the 1967 Hyde Park gig. In a 2021 *Guardian* interview, Reed explained his *raison d'etre*: 'I'm fighting for beauty in fluidity and Harry just really understands the way gender can be restrictive.'

Whether it's ribbon-bedecked Vampire's Wife facemasks, velvet sailor berets from Yorkshire hat-maker James Pink Studio, a matcha-coloured feather boa from Gucci or customised éliou pearl necklaces, Harry Styles' accessories are always both idiosyncratic and smart. His fashion choices reflect a cultivated character, down to his nail polish, customised with a smiley face, his leather jacket that makes him look like a Rumble-Fish gang-member and his pair of zoot-suity pegged-pants that wouldn't look out of place in '30s Jazz-age Harlem.

This kind of confidence is not something every Millennial or GenZ-er boasts. Y2K heralded an

insurrection against the fashions of the past that is tricky to navigate. The late '90s incubated a new kind of fashion identity where the skinny, rich, white fantasy was no longer the only style experience portrayed as aspirational by the media. As a young editor at *i-D Magazine*, Edward Enninful framed an inclusive fashion narrative that promoted a more complete story of what beauty could be, routinely championing and featuring women of colour as cover stars, such as Naomi Campbell in 1993, Lorraine Pascale in 1996 and Alek Wek in 1998 and 2000. Photographer Corinne Day and model Kate Moss, along with designers such as Hussein Chalayan, Martin Margiela and Alexander McQueen, created thought-provoking collections that empowered and altered attitudes of what fashion could be and who it could represent. The legacy of this individualism became a blink-and-you'll-miss-it ephemeral conveyor-belt of clothing crazes, and as the millennium dawned, out-of-date, conventionally cool celebrities were replaced by influencers, and talent became just one ingredient in the recipe for fame, alongside uniqueness and niche appeal. As the cycle of fashion moves on, we come to the 2000s, where Harry connects all these chaotic cultural and sartorial dots with aplomb.

Whereas in the pre-pandemic years, fashion tended to flash and burn, over the course of COVID, sensibilities have shifted towards the sanctioning of responsible consumption – meaning that if you wear it, you have to love it.

Into this mix leaps Styles, and he has hit the ground running. He directs a shifting terrain of style, hopping, skipping and jumping his way to intercontinental pop stardom, an army of acolytes following behind. Like his hero David Bowie, Styles easily morphs and switches his looks, each one authentically becoming a sign of the time, each one loved and special. Over the course of his career, Harry has naturally developed his dress-sensibility, from his fresh sixteen-year-old skater-boy looks to his skinny St-Laurent-era Hedi Slimane silhouettes in the late 2010s – looking like an extra member of The Strokes in his Chelsea boots, tight jeans and blazers – to his glam-rock, Brian Eno-esque, glitter-and-velvet-flared Alessandro Michele Gucci epoch in the 2020s. The world has watched the evolution of his wardrobe. Harry is the quintessential 21st-century fashion icon, able to pick, mix and re-calibrate an outfit with candid delight. This book explores his journey so far.

'If you are Black, if you are white,
if you are gay, if you are straight,
if you are transgender –
whoever you are,
whoever you want to be,
I support you.
I love every single one of you. '

Harry Styles, November 2017

Boa SuperNova

' The love I've always had **from my fans and my friends,** between the two, I'm incredibly lucky to have an environment where I feel comfortable being myself and **I'm very grateful for that.** '

—Harry Styles, *Audacy Music Podcast*, December 2019

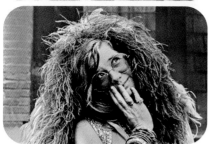

Feather boas are sartorial short-hand for rock and roll. From Belle Époque finery to roaring '20s flapper-girl extravagance, they have always added just a little *too-too-much* to an outfit – and that's exactly what rock and roll excess is about. Blues goddess Janis Joplin wore them decadently in the late '60s, as did Sylvain Sylvain from the New York Dolls in the '70s. Harry Styles took the feathers and made them his own at the 2021 GRAMMY Awards. He must be the first to pair a jet black boa with caramel slacks, as he did for the after-show digital press conference. He must be the first to wear a thistle-mauve boa with a plaid jacket and matching facemask, as he did on the red carpet when arriving at the ceremony. All very sensible boa-wearing in the world of pop-stardom, especially for the man who would walk off with the Best Solo Performance award that night. However, when he strode on stage in his black leather Gucci suit and a moss-green boa, that's when Harry's boa-busting hit a Jimi Hendrix high. Life is a cabaret, after all.

THIS PAGE TOP: *The New York Dolls, 30 October 1972, with boas and bows.*
THIS PAGE MIDDLE: *Janice Joplin with a boa on her head.*
THIS PAGE BOTTOM: *Jimi Hendrix, Monterey Pop Festival, 18 June 1967.*
OPPOSITE: *Harry Styles poses at the 2021 GRAMMY Awards on 14 March 2021, Los Angeles, CA.*

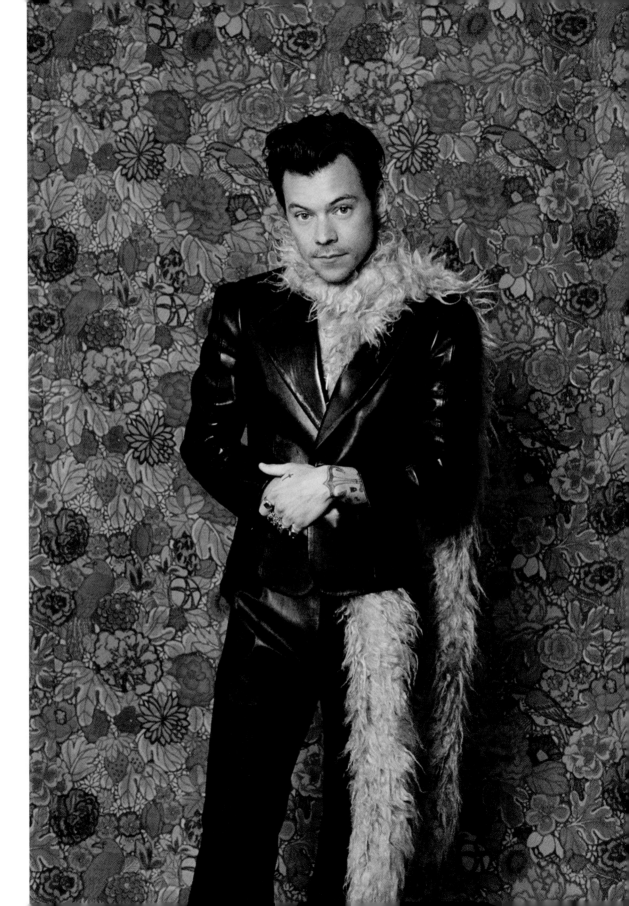

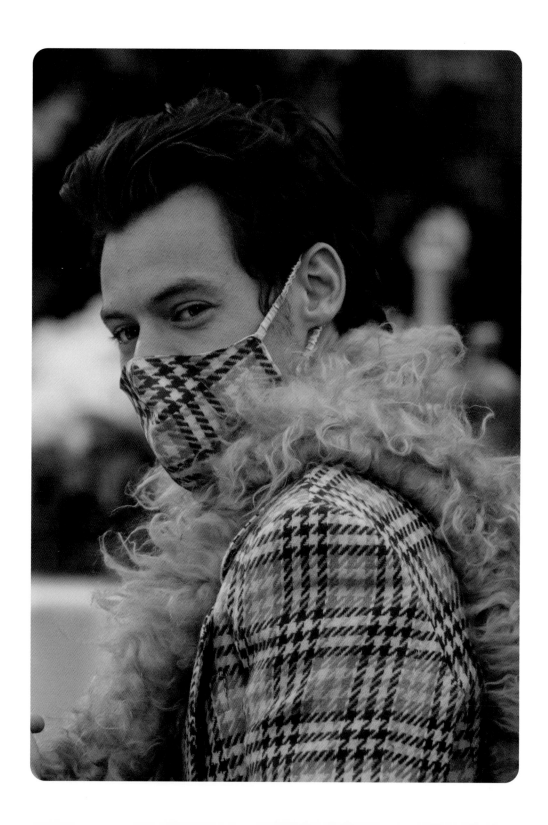

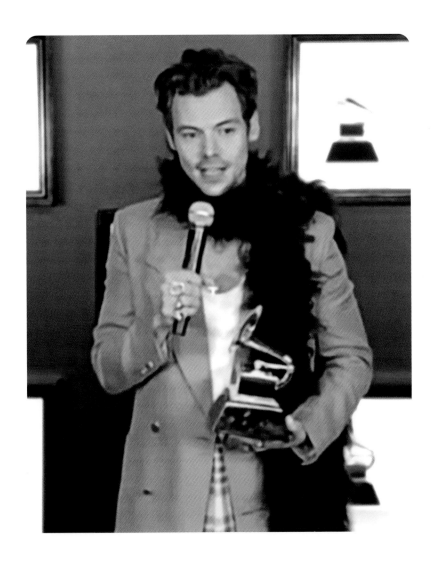

THIS PAGE: *Styles attends the 63rd Annual GRAMMY Awards Virtual Press Room broadcast on 14 March 2021.*

OPPOSITE: *Harry Styles accepts the award for Best Solo Performance at the 63rd GRAMMY Awards outside the Staples Center, Los Angeles, CA.*

Banana Smoothie

· ·

A Gucci banana necklace that Harry wore on stage at the 2021 GRAMMYs was a particularly rousing feature, as the yellow enamel skin yielded a silver phallus instead of a fruit. The talisman is reminiscent of what the Romans used to call *fascinus* charms; wearing a model of a penis was seen as lucky and usually flaunted to ward off evil and keep the wearer safe. You needed to have your eyes wide open to see Harry's version at the start of the night, snuggled as it was under his feather boa. However, as scrupulous scrutiny of Style's outfits is the best kind of fun to be had any time he steps out, it wasn't long before the digisphere spotted the epic accessory and celebrated this so very a-peeling new jewel –which is full of all the right fashionable nutrients and available in one size only.

OPPOSITE: *Harry Styles performs onstage during the 63rd Annual GRAMMY Awards at the Los Angeles Convention Center in Los Angeles, CA, broadcast on 14 March 2021.*

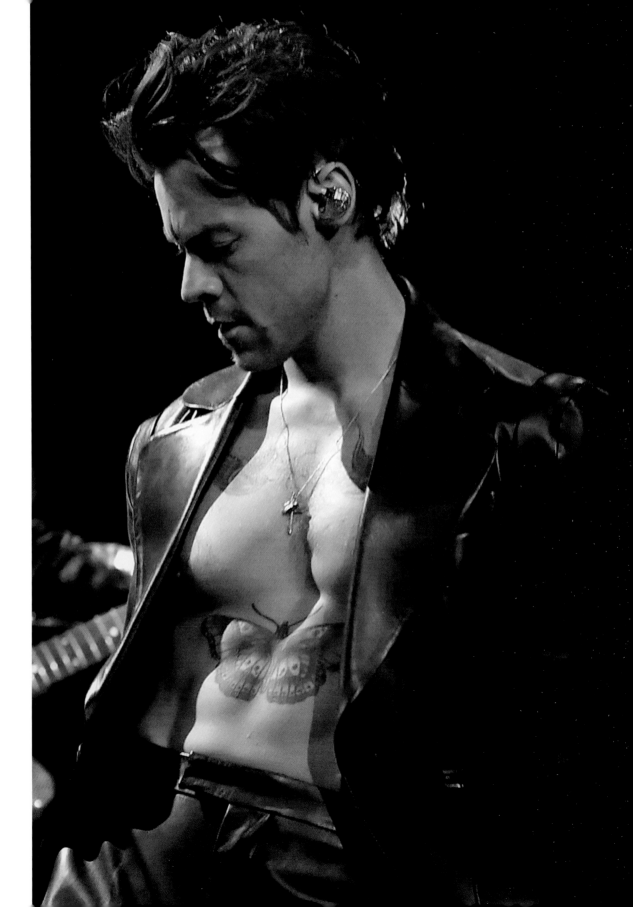

Boy with the Pearl Earring

'Alessandro Michele
is my style icon.'

Harry Styles, *Audacy Music Podcast*, December 2019.

When Harry was invited, along with Alessandro Michele, Anna Wintour, Lady Gaga and Serena Williams, to co-chair the Met Gala in 2019, it was safe to assume style heaven was on the horizon. But when fashion's most glorious night out announced that the year's theme was 'Camp: Notes on Fashion', you'd be forgiven for thinking that fashion heaven–on–earth had truly arrived.

To celebrate, Harry had his ears pierced and wore pearl Gucci earrings. Susan Sontag, in the 1964 essay that inspired the theme, explained camp taste as 'a mode of enjoyment, of appreciation – not judgement. Camp is generous. It wants to enjoy.' And Gucci designed Harry's outfit to be exactly that: delightful. Stylist Harry Lambert said afterwards, 'this is a more subtle form of camp', but on that night of a thousand stylish stars, Styles shone brighter than ever.

Michele and Styles met in 2014 and forged a fruitful fashion relationship built on mutual admiration. Michele is, Harry explained to *Vogue* in 2020, 'fearless with his work and his imagination. It's really inspiring to be around someone … like that.' Harry's sartorial spirit has flown and grown while wearing Michele's unflustered, confident collections that are awkwardly brilliant, beautiful, cool and camp. Michele has the world's finest fashionistas on speed–dial, yet has chosen Harry as his muse for many seasons. He explained his appeal in 2019, saying to *The Face* magazine that this 21st–century boy 'gathered within himself the feminine and the masculine.'

OPPOSITE: *Harry and Alessandro Michele at the 2019 Met Gala, 'Camp: Notes on Fashion', held at the Metropolitan Museum of Art, New York City, NY, on 6 May 2019.*

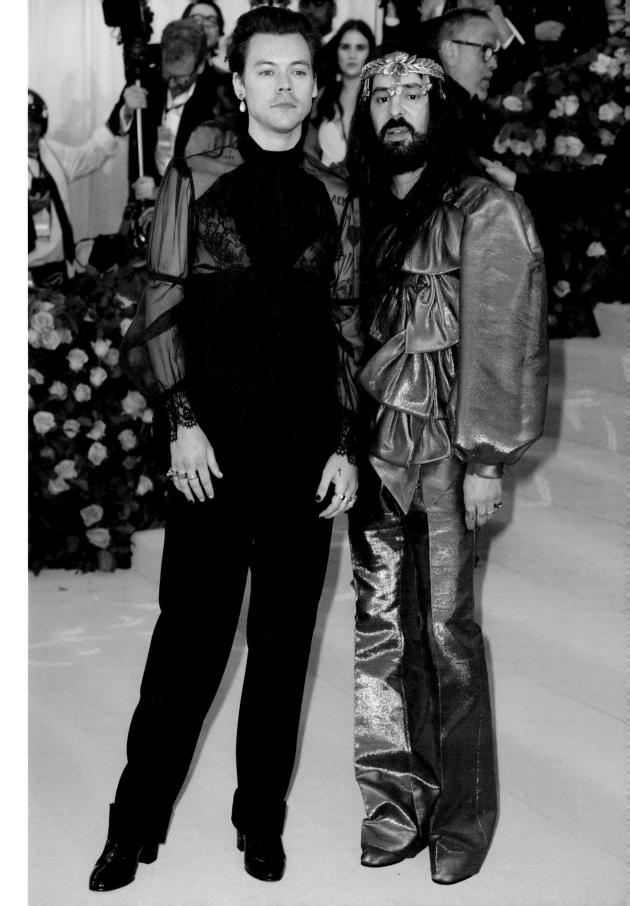

'This look is about taking **traditionally feminine elements** like the frills, heeled boots, sheer fabric and the pearl earring, but then **rephrasing them as masculine pieces** set against the high-waisted tailored trousers and his tattoos. The look, I feel, is elegant. It's camp, but still Harry. '

Harry Lambert, *Miss Vogue*, 2019.

' Camp taste is
a mode of enjoyment,
of appreciation –
not judgement.
Camp is generous.
It wants to enjoy. '

Susan Sontag, *Notes on 'Camp'*, 1964.

Mellow Yellow

· ·

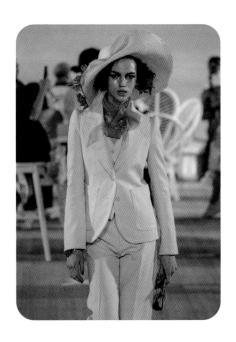

A sunflower-yellow suit from US designer Marc Jacobs' Spring/Summer 2020 collection, worn by Harry at his first BRIT Awards as a solo artist in 2020, took polysexual fashion statements into the wider mainstream and showed how lovely a purple chiffon scarf tied in a bow can look on everybody. Fashion's new inclusive reality reveals just how old-school gender-specific clothing is, and Styles' second wardrobe change of the evening (he had three) was coincidentally the same marigold suit worn by Lady Gaga on the December 2019 cover of *Elle* magazine.

' Marc has long been a believer that **clothing itself is not inherently gendered,** rather society norms have previously determined certain garments are for certain people. **[We] see a great deal of hope in today's youth,** that these limiting "rules" are increasingly no longer relevant, **with a renewed courage to be oneself.** '
—Eric Marechalle, CEO of Marc Jacobs International, *Women's Wear Daily*, 2020

THIS PAGE: *A model walks the runway at the Marc Jacobs' Ready-to-Wear Spring/Summer 2020 fashion show during New York Fashion Week, on 11 September 2019.*

OPPOSITE: *Harry Styles attends The BRIT Awards 2020 at the O2 Arena, London, UK, on 18 February 2020.*

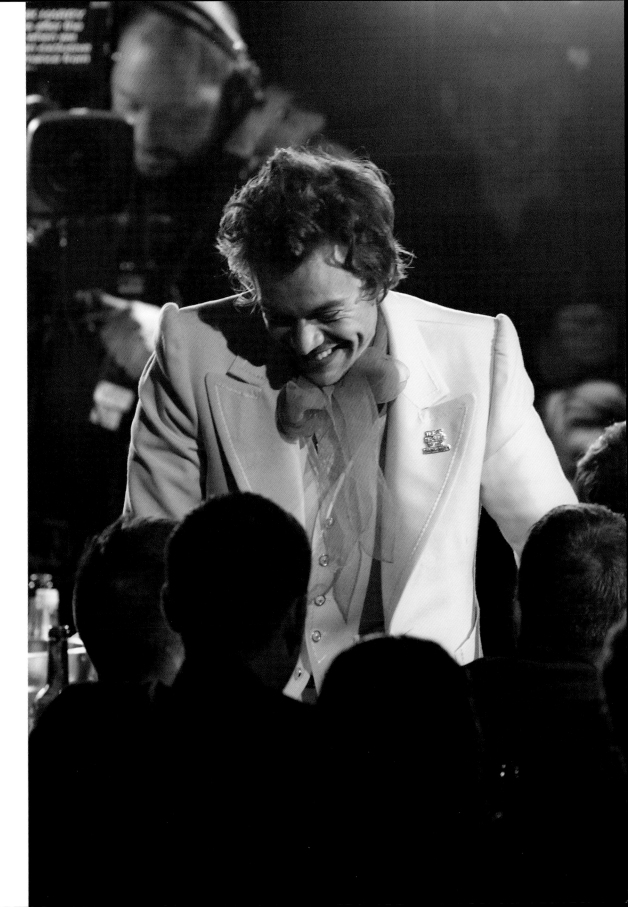

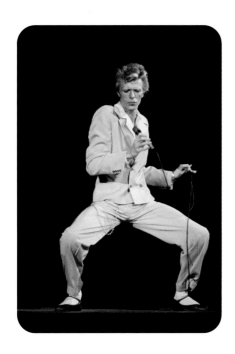

David Bowie is one of Harry's heroes – which should hardly come as a surprise. Bowie trailblazed several nonbinary pop personae in the 1970s, including Ziggy Stardust, but he never stuck to just one look. He famously said he 'collected personalities', and those personalities infused his wardrobe. Styles follows suit, especially in this peppermint Givenchy Spring/Summer 2018 outfit, which is entirely reminiscent of the one Bowie wore Styles follows suit, especially in this peppermint Givenchy Spring/Summer 2018 outfit, which is entirely reminiscent of the one Bowie wore in concert during his Diamond Dog tour at the Universal Amphitheatre in LA in 1974. By this time, Bowie had begun playing around with traditional menswear and was often seen wearing a sharp suit – but, as seen here, he favoured non-stereotypical shades that lent an ambiguous edge. Harry's matching mint shirt and suit, worn for the Victoria's Secret show in Shanghai, pre-dates his unreservedly ambisexual wardrobe of the early 2020s. But, designed in the Clare Waight Keller era of Givenchy, it retains a feminine feeling that characterises Styles' own fashion sensibility.

THIS PAGE: *David Bowie in concert, Diamond Dog tour, Universal Amphitheatre in Los Angeles, California, 5 September 1974.*
OPPOSITE: *Harry Styles performs on the catwalk for the Victoria's Secret Fashion Show at the Mercedes-Benz Arena in Shanghai, China, November 2017.*

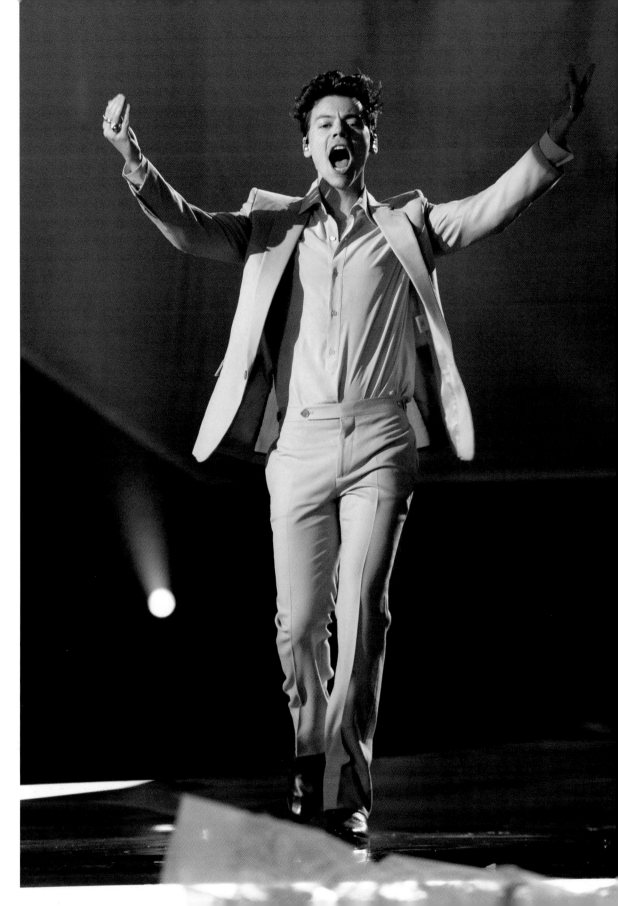

J'adore

The press pictures from Harry Styles' 'Live on Tour' 2018 are a shimmering smorgasbord of designer brands, from Givenchy to Gucci, Charles Jeffrey to Calvin Klein. But this glittering grey Saint Laurent suit by Anthony Vaccarello, worn by Harry in Paris, was the most fitting love-letter imaginable to the City of Lights and its most famous fashion house. Matched with an undone ruffled black shirt, Styles channelled nonchalant Serge Gainsbourg cool while whipping his audience into an ecstatic frenzy. Styles sparkled that night, in more ways than one.

OPPOSITE: *Styles performs during his European tour at Accor Arena on 13 March 2018 in Paris, France.*

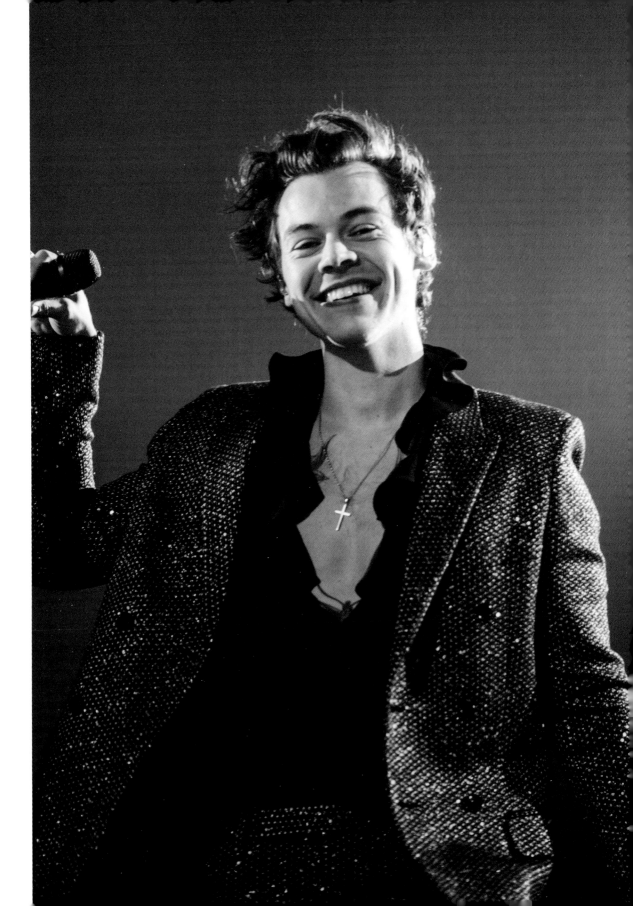

Heart and Soul

A 1970s tuxedo suit trimmed with pink crystal, paired with a Beau-Brummel cravat tied high on the neck, is exactly the kind of super-fly outfit soul singer Curtis Mayfield might have rocked in the '70s. Fast-forward to 2018: Harry looked fresh while wearing the Gucci version at the Royal Arena in Copenhagen. Mayfield has gone down in history for his socially active song-writing, but also for his funkily confident fashion sense. Like Styles, Mayfield loved to strut the stage in oversized lapels and flares, and he was equally unafraid of carrying a handbag.

> ' Today, it's easier to embrace masculinity in so many different things. I definitely find – through music, writing, talking with friends and being open – that some of the times when I feel most confident is when I'm allowing myself to be vulnerable. '
>
> **Harry Styles,** *Vice*, **December 2019.**

THIS PAGE: *Curtis Mayfield, soul singer-songwriter and recording artist, in New York City, NY, 1973.*

OPPOSITE: *Styles performs a live concert at the Royal Arena in Copenhagen, Denmark, March 2018.*

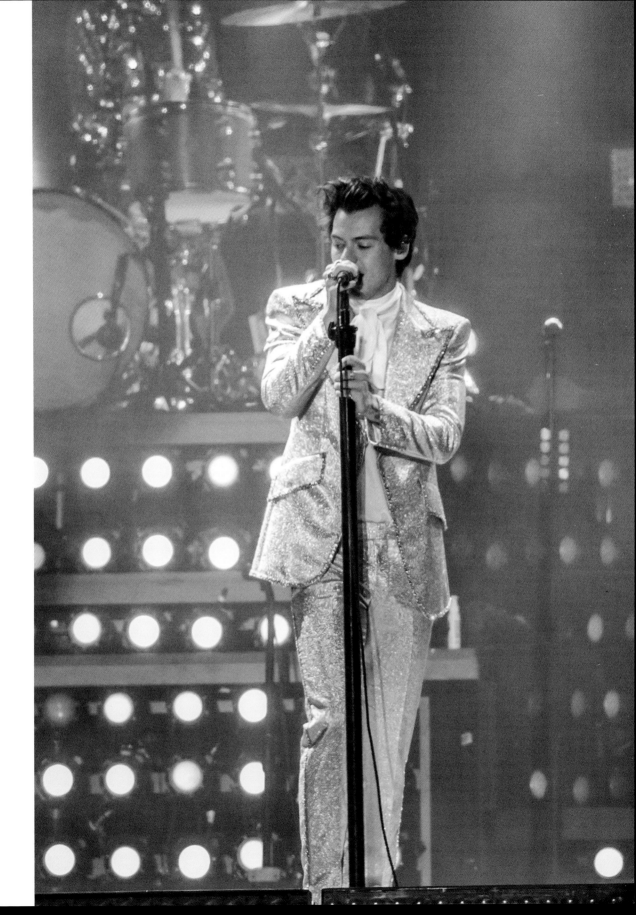

Bags of Character

Nails, rings, handbag: check. Harry stepped onto the BRITs red carpet in 2021 looking immaculate, wearing a geometric Autumn 2021 Gucci suit that was designed to celebrate in. And, of course, he did – winning Best Single for 'Watermelon Sugar'. Harry never fails to have fun with fashion, and while looking on-point signature stylish, he still managed to court just a tiny bit of controversy over his unashamed man-bag-carrying. The caramel-coloured, bamboo-handled 'Jackie' – named after the utterly elegant First Lady, Jackie Kennedy – is a relaunched classic from Gucci's 100-year-anniversary Aria collection, which still carries cool cache today.

' The bag of the century
and the suit of dreams. '
—Harry Lambert, @harry—lambert, 11 May 2021.

OPPOSITE: *Harry Styles wins the Mastercard British Single Award for 'Watermelon Sugar' during the BRIT Awards 2021, at the O2 Arena on 11 May in London, UK.*

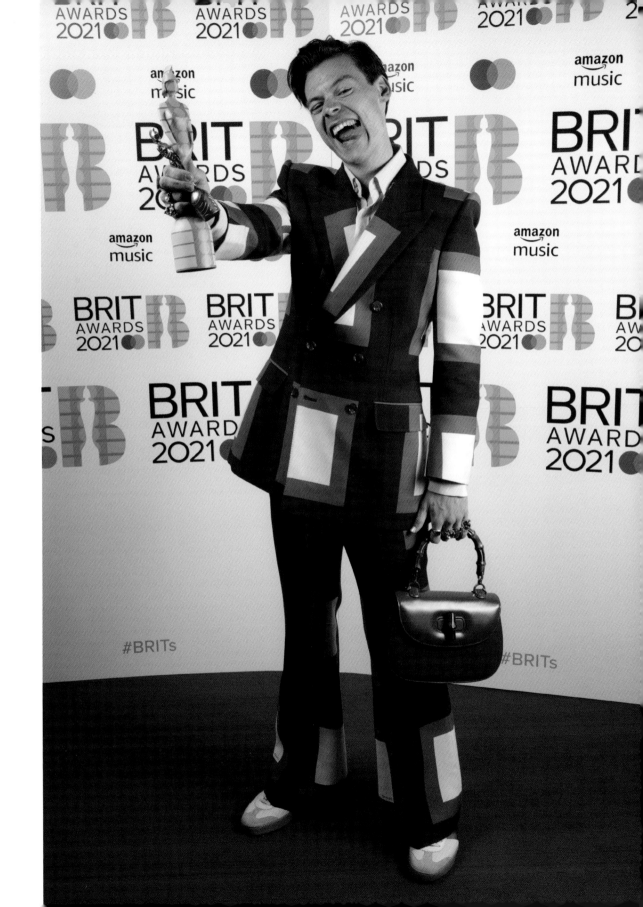

Pearl's a Winner

‘ The coolest things are
not always the cool things.
Do you know what I mean? ’
—Harry Styles, *The Guardian* newspaper, December 2019.

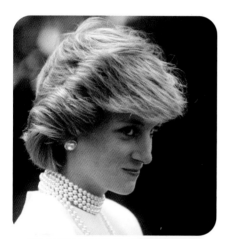

Pearls hint at old–money glamour, and though they aren't always in fashion, much like diamonds, they've always been a girl's best friend. Or a boy's – or anyone else's, for that matter. Coco Chanel, Jackie Kennedy, Little Richard, Princess Diana and Harry Styles have all conquered the fabulously classy challenge of wearing pearls with panache. The versatility of these jewels is not lost on Styles. He knows how to dress down a string – such as when he sang Joni Mitchell's 'Big Yellow Taxi' on Radio 2 in 2020. Pairing pearls with a green Bode appliqué jacket and Gucci slacks, he effortlessly gave hippie '70s vibes a hypermodern twist. Styles knows how to subvert fashion, and for a visit to SiriusXM studios in NYC, he epitomised technicolour norm–core, wearing his pearls with a Gucci lace–collared blouse and pea–green pegged trousers. Pearls are a counterintuitive rock and roll sensation; Little Richard loved wearing them while sweaty and shirtless in the '70s, and Styles, embracing Sloane Ranger chic, wore them with Princess Diana frills at the 2020 BRIT Awards.

THIS PAGE TOP: *Princess Diana, during a tour of Canada on 30 June 1983.*
THIS PAGE BOTTOM: *Little Richard on stage at Wembley Rock Festival, 5 August 1972.*
OPPOSITE: *Styles arrives at the BRIT Awards, 2020, at the O2 Arena in London, UK.*

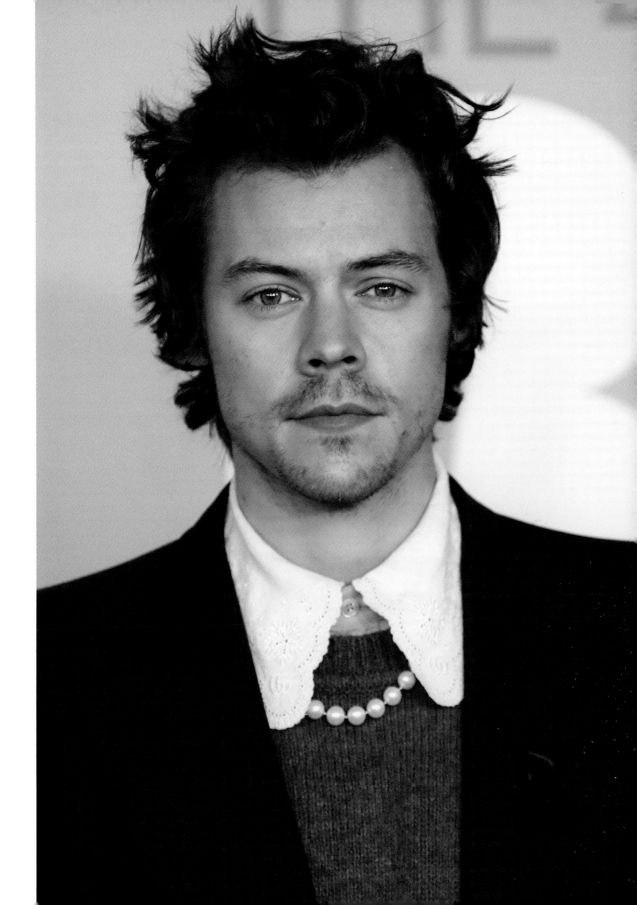

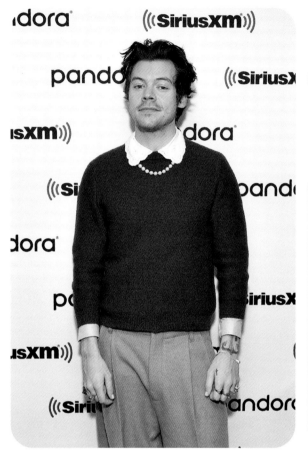

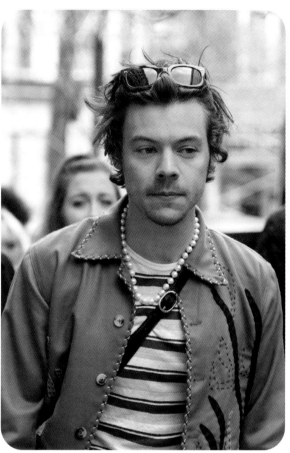

THIS PAGE LEFT: *Styles visits SiriusXM Studios on 2 March 2020 in New York City, NY.*

THIS PAGE RIGHT: *Styles leaves the BBC Radio studios in Wogan House, London, UK, pairing pearls and sunglasses.*

OPPOSITE: *Spotify celebrates the launch of Harry Styles' new album with a private listening session for fans on 11 December 2019 in Los Angeles, CA.*

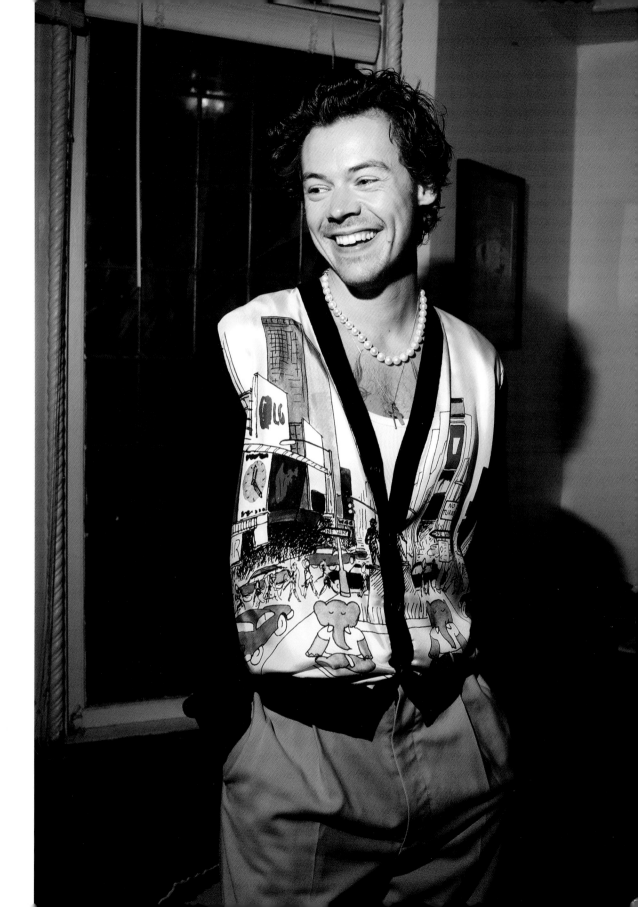

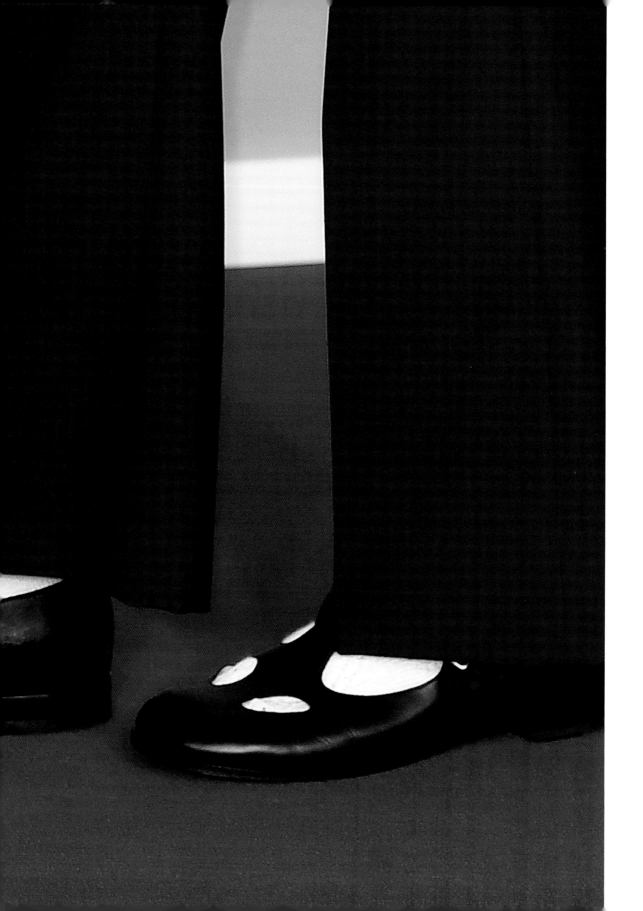

Shoe Me Heaven

· ·

It is uncommon for adults to wear little girls' shoes – unless they are fans of Harajuku. This Japanese subculture, which hit its high in the '80s, revolved around looking cutely confident and using clothes with humour. When Styles stepped out in a pair of black Gucci Mary–Janes at the BRITs, he demonstrated his playful approach to clothes and made an intrepid reference to the Harajuku fashion statement. However, where angels fear to tread, the biggest and boldest rockstar of them all, Elton John, will inevitably have been before. Harry is a massive fan of the Rocketman, who is celebrated for his exuberant footwear. Needless to say, John used to wear his own version of dolly–shoes, but only as a low–key look in the '70s, while hanging out in hotels between gigs.

> ' I quit shoelaces
> a long time ago. '
> —Harry Styles, Twitter, July 2012.

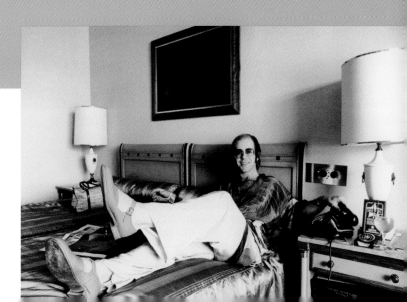

THIS PAGE: *British singer Elton John relaxing in his hotel room at the Inn On The Park, 1970s.*
OPPOSITE: *Shoe detail as Styles attends the BRIT Awards 2020 at the O2 Arena on 18 February 2020, London, UK.*

Man in Black

When Chanel introduced black as a fashion colour for women in the 1920s, it was a revolution. It felt instantly chic and a little subversive following the sweet–pea shades of the Belle Epoque era. For men wearing a black shirt under a black suit is an equally elegant statement and one that the likes of labels such as Prada and Helmut Lang know the virtue of and first platformed in the '90s with a minimalist slant. Black on black is also a magnificent cool code in the wardrobe of rock and roll and a signature style of the quintessential radical and outlaw country and blues god, Johnny Cash, who wore it on stage and off. Just like his 1972 track 'Man in Black', he was synonymous with the shade, and it fitted his dark, brooding persona well. When Harry was moved to sport similar at the *Dunkirk* movie premier in New York in 2017, he displayed his Cash allegiance by wearing the monotone look with cowboy boots and silver rings; now he was a serious challenger not just in the worlds of music and fashion, but film too. Harry's suit was from the Raf Simons–designed Calvin Klein 205W39NYC label, which was a short–lived, slightly conceptual runway line that hit the headlines for its energising re-imaging of American sartorial codes. It was a much–loved favourite with fashion insiders and, therefore, a natural fit for Harry.

THIS PAGE: *Country and blues singer Johnny Cash, circa 1965.*
OPPOSITE: *Harry Styles at the* Dunkirk *New York Premiere, New York City, 19 July 2017.*

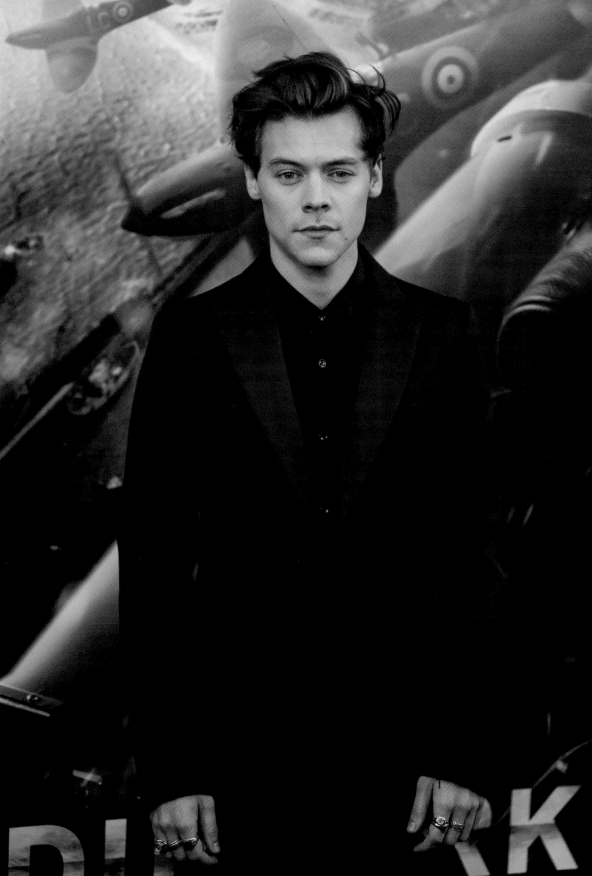

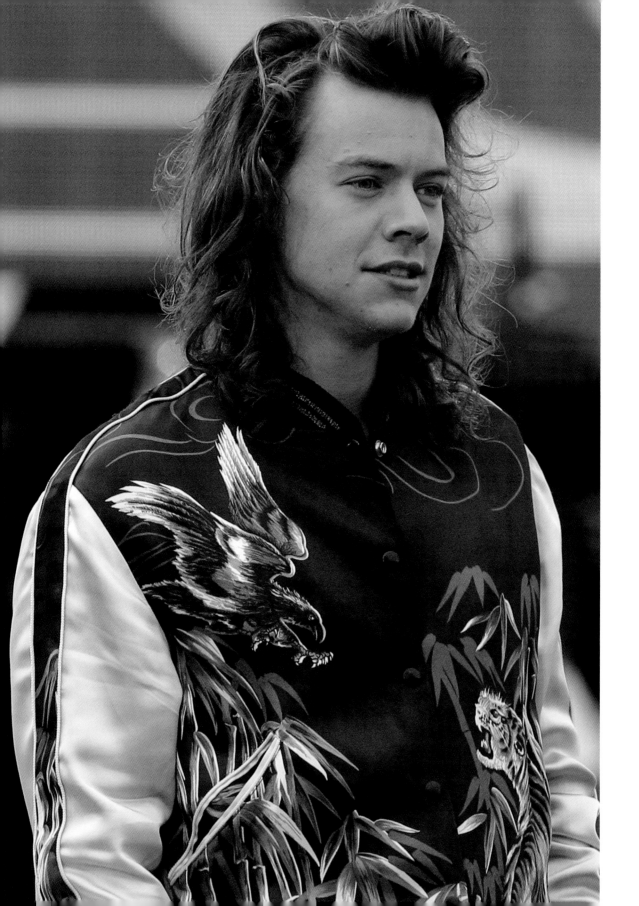

Silk Route

· ·

Silk tour jackets are a symbol and souvenir of war-time travel and active service. Also known as *Sukajan*, they first became popular after the Second World War when American GIs returning from Japan brought home embroidered versions, often decorated with maps of the areas where they had been stationed. The bomber-silhouette became a bit of a trend and, later, during the 1950–1953 Korean War, soldiers commissioned hand-made versions and bought them in droves. They are synonymous with that decade and as such have a special place in the world of collectible vintage fashion that echoes a nostalgia for a moment in time when everything was gilded with the backbeat of rock and roll. Tour jackets are highly prized today and fine examples are sought after by nerdy fashion aficionados the world over, fetching thousands of dollars and pounds at specialist auctions and re-worn or framed as a subversive, counter-cultural statement. So, it was only a matter of time before Hedi Slimane, the designer most inclined to synthesise subcultural design obsessions and make them his own, decided to create his very own versions. For a Spring-Summer 2016 Yves Saint Laurent Menswear collection, Slimane showed a high-fashion adaptation made from luxe satin, printed with eagles, palm trees and classic tiger motifs teamed with grungy checked shirts, skinny black jeans, and white plastic Kurt Cobain shades. As usual with an underground look, it was a code that those in the know promptly understood and acknowledged; the YSL tour jackets sold out immediately and were seen on the backs of only the most connected. Harry, of course, managed to acquire one of his own and metamorphosed it into a personal, outsider-glam, savvy sartorial statement that tapped into a burgeoning and ongoing vintage aesthetic revival that has become very much part of the 21st-century approach to fashion moments that don't go out of style.

OPPOSITE: *Harry Styles onstage during ABC's* Good Morning America *at Rumsey Playfield, Central Park, NYC, 4 August 2015.*

Sound and Vision

Is there any style statement groovier than a rockstar in a sassy pair of shades? Sunglasses might be useful under the bright rays of LA but, more importantly, they are a spot-on accessory that sings of cool. From Elton John's signature coloured lenses to the wrap-arounds permanently glued to the nose of U2 frontman Bono, shades have staked their claim on fashion history. Harry donned an inspired summery selection in his music video for 'Watermelon Sugar', including a water-effect sea-blue pair, a round sepia pair, and of course, the iconic red heart-shaped set. His red plastic pair, worn to warm up before his appearance on *The Late Late Show*, are another red-hot addition to his wardrobe.

OPPOSITE: *Harry Styles is seen on 20 November 2019 in Los Angeles, CA (*The Late Late Show, *James Cordon).*

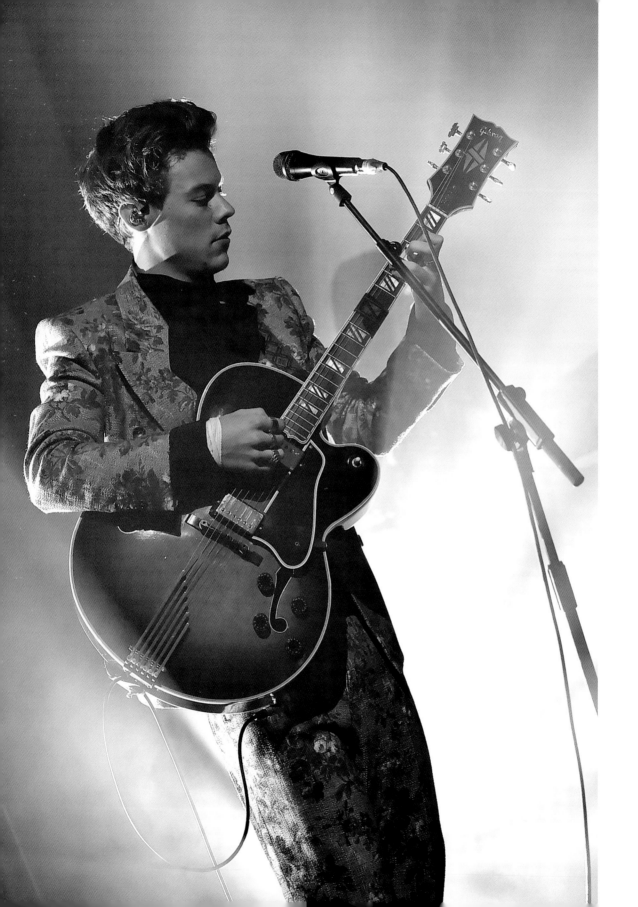

Blossoming

Harry's fondness for floral suits has opened up an exciting new wardrobe for all kinds of folk. He wore one such garment at the Greek Theatre gig in LA as part of his 2017 *Live on Tour* shows, which had the self-proclaimed 'QueerPop' band Muna opening for him. His LGBTQ+ friendly concerts that year saw him dancing draped in rainbow flags while the audience cheered him on. Banners in the crowd asked everyone to 'Always Choose Love'. Inclusivity is part of Harry's DNA, and in April 2021 he was shortlisted as an icon for the British LGBT Awards, while 2022 sees him playing a gay policeman in a new Amazon Studios film, *My Policeman*. Dressing in blossoms isn't a big deal for Harry, who has an assertive approach to clothes, but choosing to do so helps his campaign for kindness. Truly, clothes speak volumes.

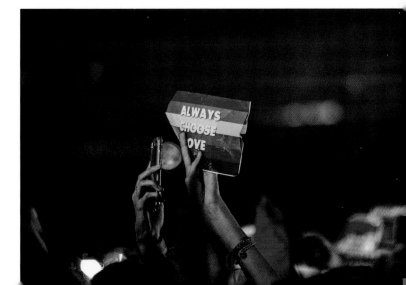

THIS PAGE: *Pride banner in the audience during the Harry Styles concert at Olympia Hall, Paris, France on 25 October 2017.*
OPPOSITE: *Harry Styles performs onstage at the Greek Theatre on 20 September 2017 in Los Angeles, CA.*

Goodfella

The Gucci Cruise 2020 collection was shown in Rome and, as one of Alessandro Michele's chosen faces, Harry's style quotient jumped the shark. Wearing a cream suit, a GG Marmont raffia clutch bag and rose-tinted shades, with a matching blush manicure featuring a pale blue highlight, Harry worked the '70s in an avant-garde fashion. However, if you look closely at some of the remarkable clothes worn by men in the disco era – including the wardrobe of the brilliant Bee Gees and their signature white flared suits – it's easy to see where the inspiration lies. It's good to see glam-for-men staying alive.

' Be
yourself. '
—Harry Styles, *The Howard Stern Show*, March 2020

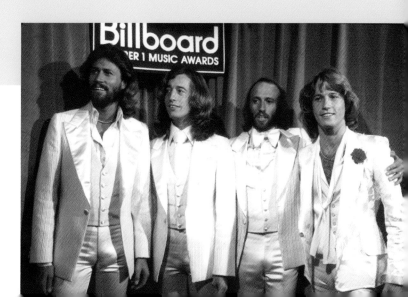

THIS PAGE: *Bee Gees – Barry Gibb, Robin Gibb, Maurice Gibb and Andy Gibb at the Billboard Music Award, 1977.*
OPPOSITE: *Rome, Gucci Cruise Parade at the Capitoline Museum, 28 May 2019.*

Think Pink

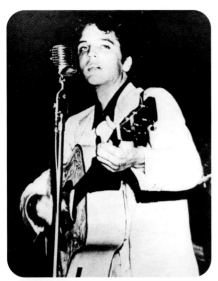

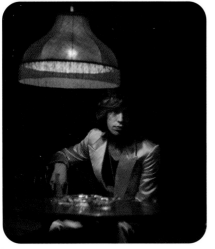

Thanks to Elvis Presley, there is nothing more rock-and-roll than a pink suit, a black shirt and a big greased quiff: a combo he wore on stage back in 1955. Harry revealed in a 2019 *Rolling Stone* interview that the first music he ever heard was Elvis Presley, and on *The Today Show* Harry Styles paid sartorial homage to The King, shaking up the audience while dressed in a similar baby-pink Edward Sexton bespoke suit and a classic black shirt. With his '50s floppy quiff and guitar slung over one shoulder, he certainly looked equally fine. In an *Esquire* interview, the tailor Sexton remarked: 'The flamboyance of Elvis's stage-wear liberated men to wear clothes that were more outrageous than they had worn since the nineteenth century.' Sexton is the go-to name for groovy suiting. In partnership with Tommy Nutter back in the '70s, he famously dressed all the beautiful people in his cut for men and women, including Mick Jagger who wore Sexton when he married Bianca in 1971. Now, in the 21st century, Styles heroically keeps the allegiance alive.

THIS PAGE TOP: *Elvis Presley, performing live on stage, 1955.*
THIS PAGE BOTTOM: *Mick Jagger dressed in pink satin suit by Sexton, 1970.*
OPPOSITE: *Harry Styles performs on NBC's* Today Show *at Rockefeller Plaza, New York City, NY, on 9 May 2017.*

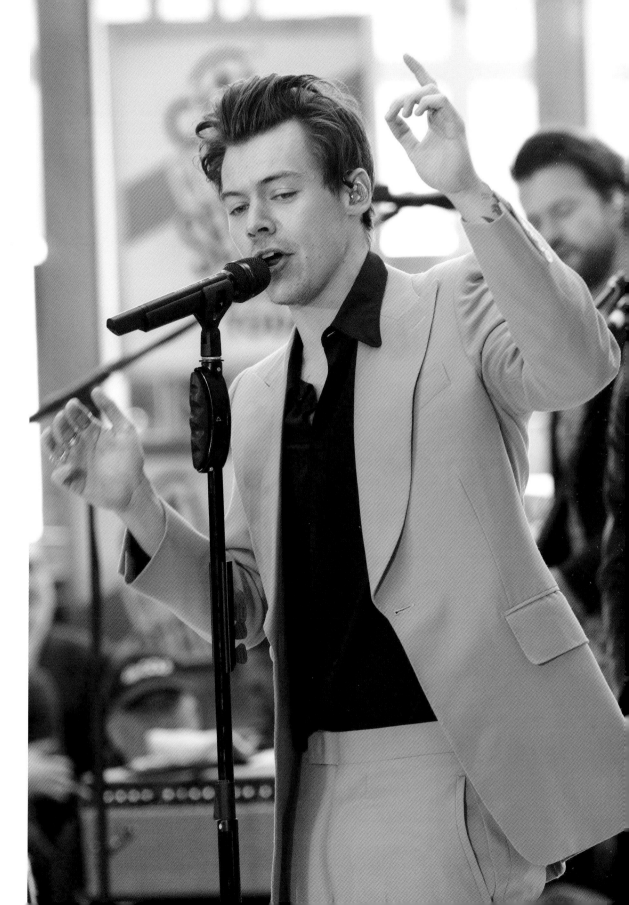

'Pink is the only true
rock-and-roll colour. '

Paul Simonon, quoted by Harry Styles,
***Rolling Stone* magazine, April 2017.**

' Sexton remarked:
The flamboyance of Elvis's stage–
wear liberated men to wear
clothes that were
more outrageous
than they had worn
since the nineteenth century. '
Now, in the 21st century,
Styles heroically keeps
the allegiance alive.

Velvet Crush

· ·

'Being so unapologetically herself, she [Stevie Nicks]
gives others permission to do the same. '
—Harry Styles, Rock & Roll Hall of Fame Induction Ceremony, 2019.

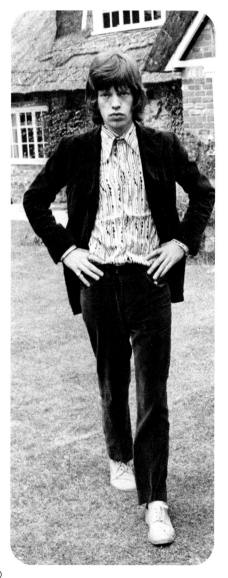

The blue velvet Gucci suit Harry wore to induct rock goddess and fashion muse Stevie Nicks into the Rock & Roll Hall of Fame in 2019 made such an impression that it was picked to go into their permanent 'Right Here, Right Now' exhibition as an example of 'clothes that define an era'. The dandy outfit first starred on Styles in the Gucci Pre–Fall 2019 campaign, shot by photographer Glen Luchford. Men in velvet looked groovy in the late '60s, when Nicks' band, Fleetwood Mac, first became iconic. Those were the days: when Mick Jagger, another of Styles' style champions, also played around with gender theory, proving that frills, ruffles and velvet don't exclusively belong in the feminine wardrobe.

THIS PAGE: *Exclusive image of Mick Jagger wearing velvet in the gardens at Redlands, 1967, by David Cole.*
OPPOSITE: *Harry Styles and Stevie Nicks at the 2019 Rock & Roll Hall of Fame Induction Ceremony at the Barclays Center, Brooklyn, New York City, NY, on 29 March 2019.*

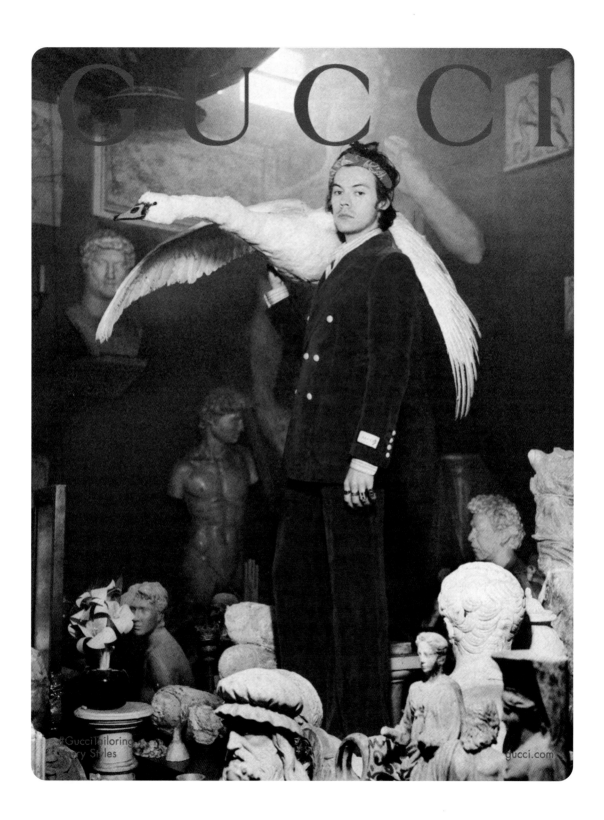

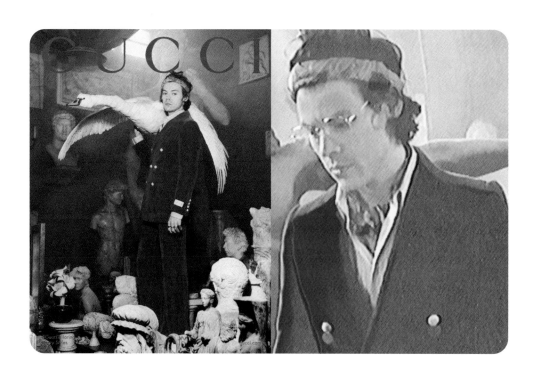

THIS PAGE AND OPPOSITE: *Harry Styles featured in Pre–Fall 2019 Gucci Collection magazine advert, UK.*

Styles Saint Laurent

‘ I think with music it's so important to evolve, and that
extends to clothes and videos and all that stuff.
That's why you look back at David Bowie with Ziggy Stardust
or The Beatles and their different eras –
that fearlessness is super inspiring. ’
—Harry Styles, *US Vogue*, December 2020.

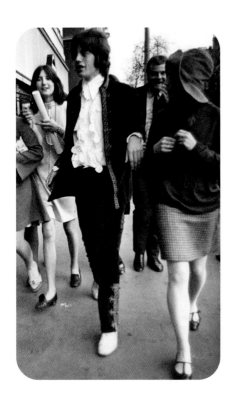

While still with One Direction, Harry made some of his earliest fashion statements wearing Hedi Slimane–era Yves Saint Laurent. Slimane's love of stove–pipe jeans, subculture and teenage kicks translated perfectly for Harry, who incarnated a youthful Mick Jagger in the '60s, beatnik and bohemia united. Both Harry and Hedi adore music and fashion; theirs is the perfect union.

THIS PAGE: *Mick Jagger of The Rolling Stones and Marianne Faithfull, 1967.*
OPPOSITE: *Harry Styles of One Direction performs onstage at the 2014 American Music Awards at Nokia Theatre L.A. Live in Los Angeles, CA, on 23 November 2014.*

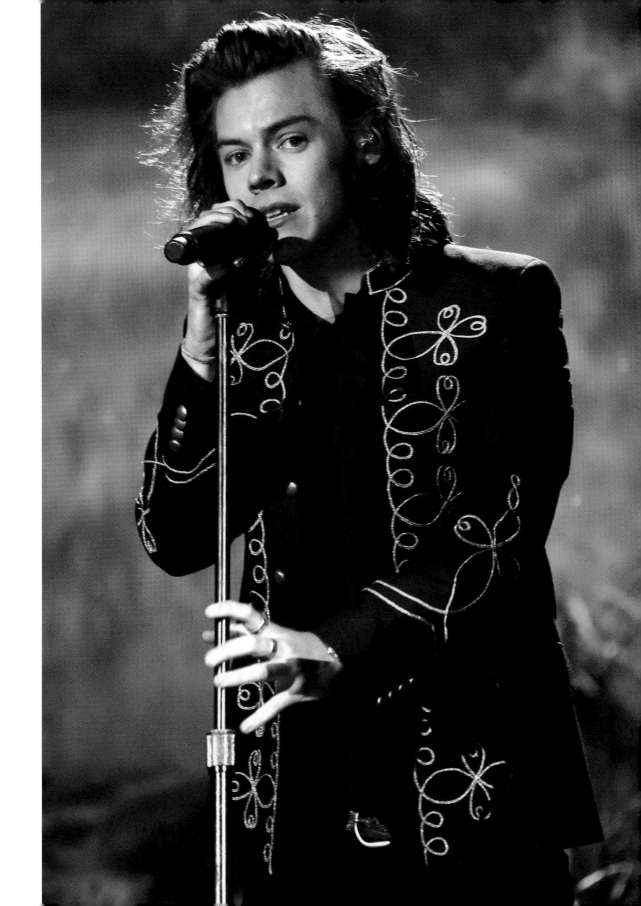

'Music has shaped men's fashion and transposed in a playful and witty manner its riding or military heritage. It is difficult to figure out who leads, but music and fashion are connected genetically. ,

Hedi Slimane, *WWD***, March 2011.**

Styles at the 2014 American Music Awards.

Thrill of the Frill

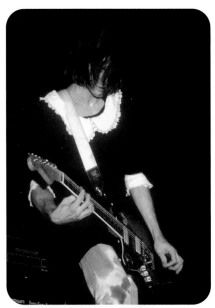

Although on first glance a frill signifies total femininity, fashion history tells us it's a unisex flourish that has been regularly worn by men: poets, pirates and peacocks have all paraded frills with a passion. Frills are also a signature of flamboyant singing legend Little Richard. Long before genderfluidity was acknowledged, the Tutti–Frutti singer declared: 'If Elvis is the King, then I'm the Queen of Rock and Roll'. Nirvana frontliner Kurt Cobain loved frilly cuffs and collars and wore them as decoration on his dresses during the gala–grunge years of the '90s. Harry likewise loves a flouncy edge and has experimented fearlessly since the days of One Direction.

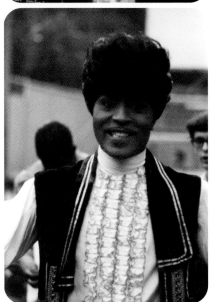

THIS PAGE TOP: *Singer Kurt Cobain of Nirvana performs in concert on 27 December 1991 at the Forum in Los Angeles, CA.*
THIS PAGE BOTTOM: *Little Richard in a ruffled shirt, circa 1970, New York City, NY.*
OPPOSITE: *Dave Gardner and Harry Styles attend the launch of docufilm* Annabel's: A String of Naked Lightbulbs *at Annabel's nightclub on 28 October 2014 in London, UK.*

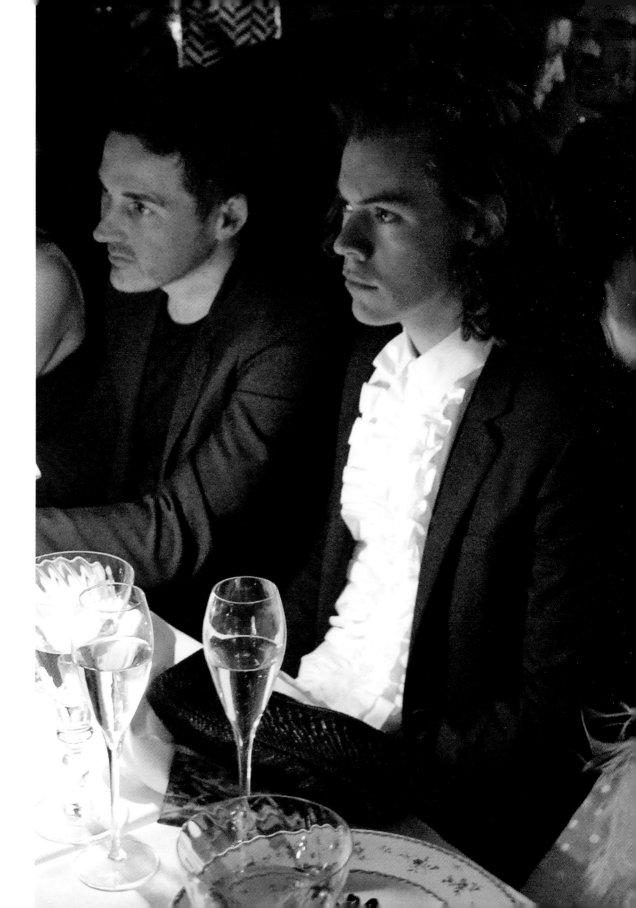

Creature Feature

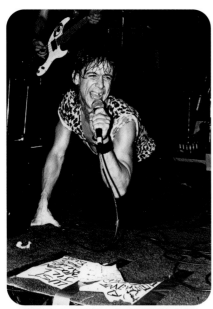

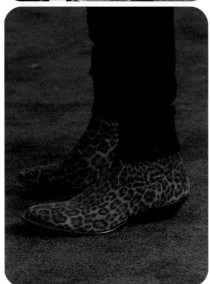

From street to couture, from punk to pop, a leopard print is an empowering motif that *roars*. In fashion it can be a tiny bit trashy, but when worn onstage – like by Iggy Pop in the '70s, with broken teeth bared in a snarl and hair sticky with sweat – it's an unmitigated riotous spectacle. The appeal is easy to see, and when Harry began his flirtation with fashion, going to catwalk shows in London, 2013, it was leopard print, courtesy of Burberry Prorsum and Saint Laurent, that helped him feel camera-ready on the red carpet.

THIS PAGE TOP: *Iggy Pop, performing circa 1980.*
THIS PAGE BOTTOM: *Harry Styles [Shoe Detail] attends the 2014 American Music Awards at Nokia Theatre L.A. Live (now Microsoft Theater) on 23 November 2014 in Los Angeles, CA.*
OPPOSITE: *Harry Styles arrives at Burberry Prorsum Womenswear Spring/Summer 2014 show during London Fashion Week at Kensington Gardens, London, UK, on 16 September 2013.*

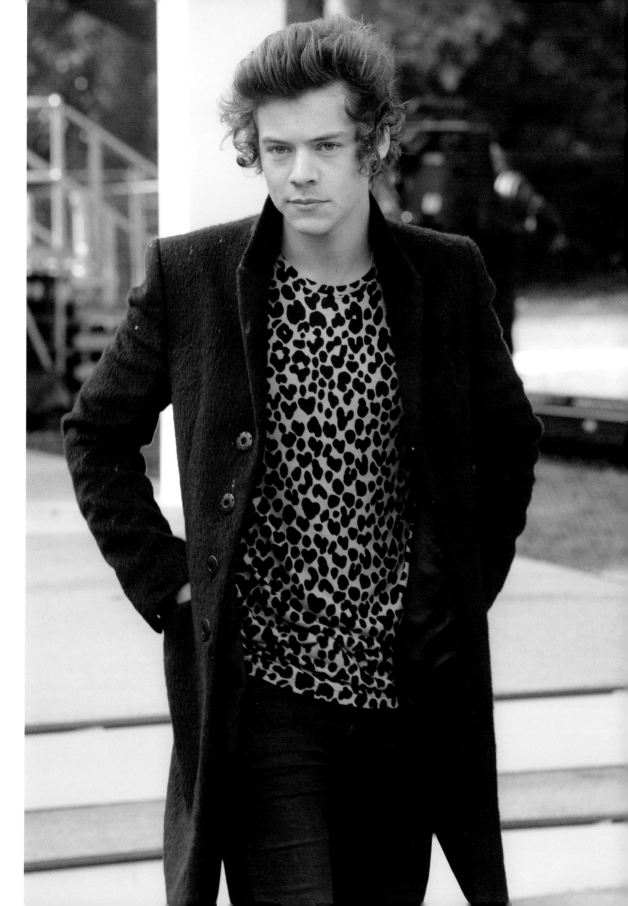

Headcase

· ·

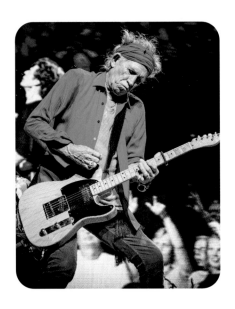

After getting his first tattoo on his 18th birthday in 2012, Styles has moved on apace – to date, he has over 50. He loves throwing his arms in the air to show them off. One of his first was a pirate ship that looked like Captain Jack Sparrow's boat from *Pirates of the Caribbean*. After Johnny Depp revealed that Rolling Stones guitarist Keith Richards was the inspiration for his role as Jack Sparrow, Richards went on to play Sparrow's father, Captain Teague. Richards is, of course, a mega-legend in the history of rock and roll – so when Styles rocked out on stage in Copenhagen, sporting his beloved tatts and with a skull-patterned scarf wrapped around his head *à la* Richards, it became clear that Mick Jagger wasn't the only Stones style-hero who Styles felt an affinity with.

THIS PAGE: *Keith Richards performs with The Rolling Stones at TD Garden in Boston, MA.*
OPPOSITE: *Styles live on stage with One Direction, performing a live concert at Parken Stadium, Copenhagen, Denmark, June 2014.*

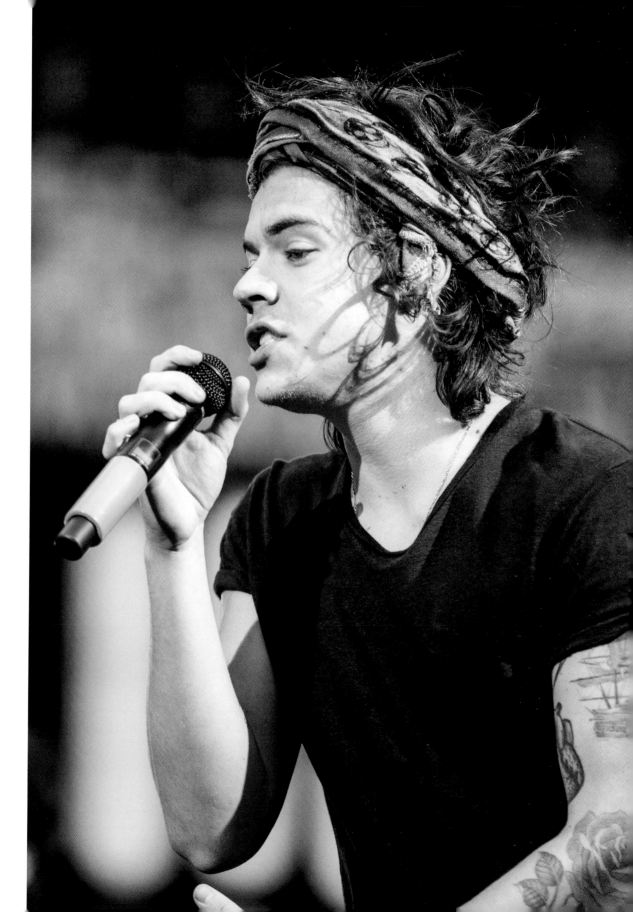

'What's the point of creating things if they don't make people think? Or feel or reflect? Especially as an artist or creative? Who wants to see the same thing all the time? And never explore their assumptions? Anyways [Styles' outfit] looks bomb, so. '

Alexandria Ocasio-Cortez,
AOC Instagram stories, November 2020.

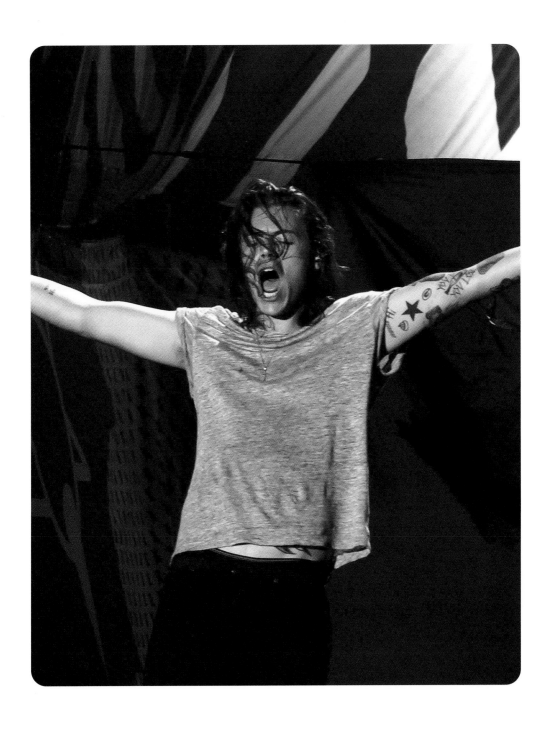

Styles performs at Arrowhead Stadium on 28 July 2015 in Kansas City, MO.

Best Foot Forward

Harry Styles loves a statement shoe and boot – and even, occasionally, a cute kicky-heel. In the look-books of footwear fabulousness, he joins the likes of '70s *Diamond Dogs*-phase David Bowie and the King of Soul James Brown, who marched out in appealing heels. Their boots were definitely not made for too much walking but, nevertheless, they un-shaped gender-norms while wearing them. Styles' modernistic, flexi-fashion approach to dressing up paves an inventive sartorial pathway, where striding out in something special shows the world exactly how fun it is to be who you want to be.

THIS PAGE TOP: *James Brown poses for a portrait, circa 1974.*
THIS PAGE BOTTOM: *Detail shot of Harry Styles' boots as he poses in the press room during the 2015 American Music Awards at Microsoft Theater on 22 November in Los Angeles, CA, where One Direction won Favourite Pop/Rock Band/Duo/Group.*
OPPOSITE: *Harry Styles attends the World Premiere of* Dunkirk *at Odeon Leicester Square in London, UK, on 13 July 2017.*

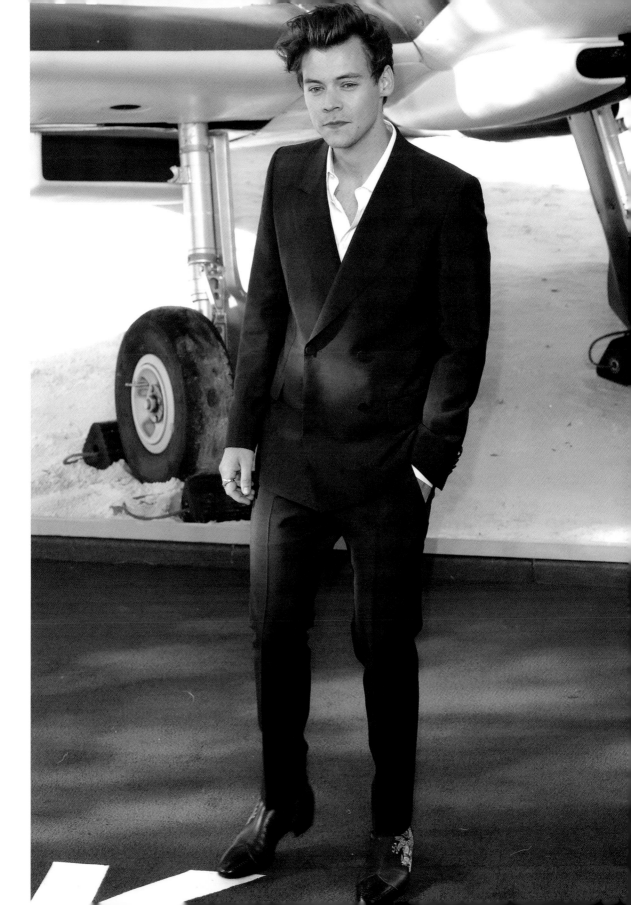

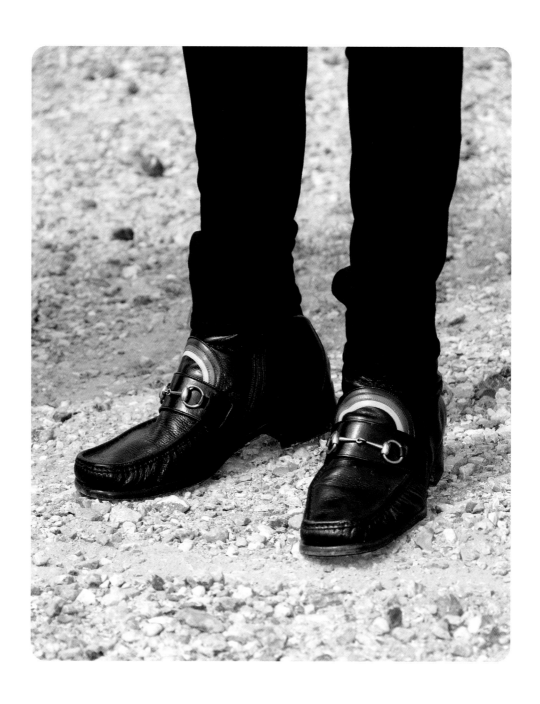

THIS PAGE: *Detail shot of Harry Styles' rainbow loafers, as he poses for the Dunkirk photocall on 16 July 2017 in Dunkerque, France.*
OPPOSITE: *David Bowie posing with a large barking dog while working on the artwork for his 1974 album Diamond Dogs in London, UK.*

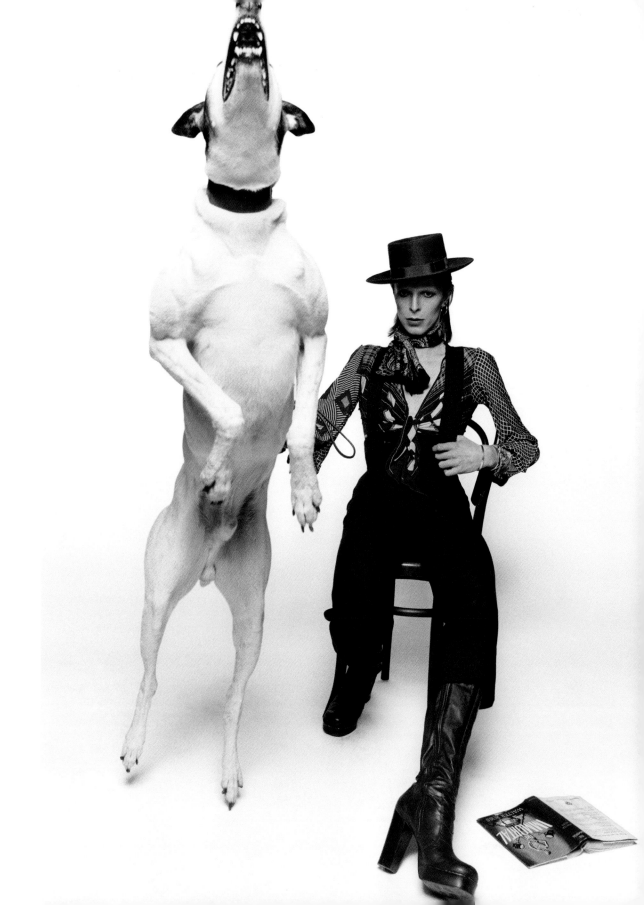

'Styles' modernistic, flexi–fashion approach to dressing up paves an inventive sartorial pathway, where striding out in something special shows the world exactly how fun it is to be who you want to be. ,

'[Harry Styles] has the aura of an English rock–and–roll star – like a young Greek god with the attitude of James Dean and a little bit of Mick Jagger – but no one is sweeter. '

Alessandro Michele, *Vogue* magazine,
'Playtime with Harry Styles' by Hamish Bowles,
13 November 2020.

Zig-a-Zig Ah

In the growth stages of Harry's fashion journey, he learnt how to pick and mix a number of super-classy high-style labels with ease. When Kim Jones was at Louis Vuitton, Styles zoomed in on his Summer 2014 collection and chose a jazzy chevron shirt to wear with a skinny tie. His long hair at the time completed his burgeoning indie-kid aura. From Ziggy Stardust's lightning strike to Louis Hamilton's metallic zig-zag suit from the 2019 Met Gala, this bold pattern signifies a desire to step outside conventional boxes and be seen. It only seems fitting that Styles embraced this snazzy striping in his early years, when he first started making a name for himself as a fashionista to follow.

OPPOSITE: *Harry Styles attends the Capital FM Summertime Ball at Wembley Stadium on 6 June 2015 in London, UK.*

Chest a Minute

· ·

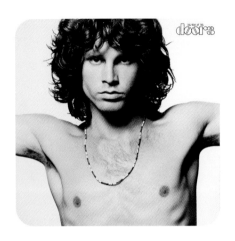

Vogue called Hedi Slimane's Saint Laurent Fall 2015 collection 'the coolest clothes on earth', and Harry, although at the time a still-evolving fashion fan, intuitively understood its allure. The just-turned-21 Styles adopted Slimane's skinny rock-and-roll silhouette, wearing a pussycat-bow satin blouse under a lean black blazer for the Billboard Music Awards in LA. Channelling poet-songwriter Jim Morrison from The Doors, Styles wore his hair windswept, with his chest and necklace on display. Morrison lived a short yet debauched life, most of it with his upper torso bared. Not at all a bad look – and one that Styles habitually returns to.

THIS PAGE: The Best of The Doors, *album cover.*
OPPOSITE: *Harry Styles, 2015 Billboard Music Awards Press Room at MGM Grand Garden Arena Las Vegas, 17 May 2015.*

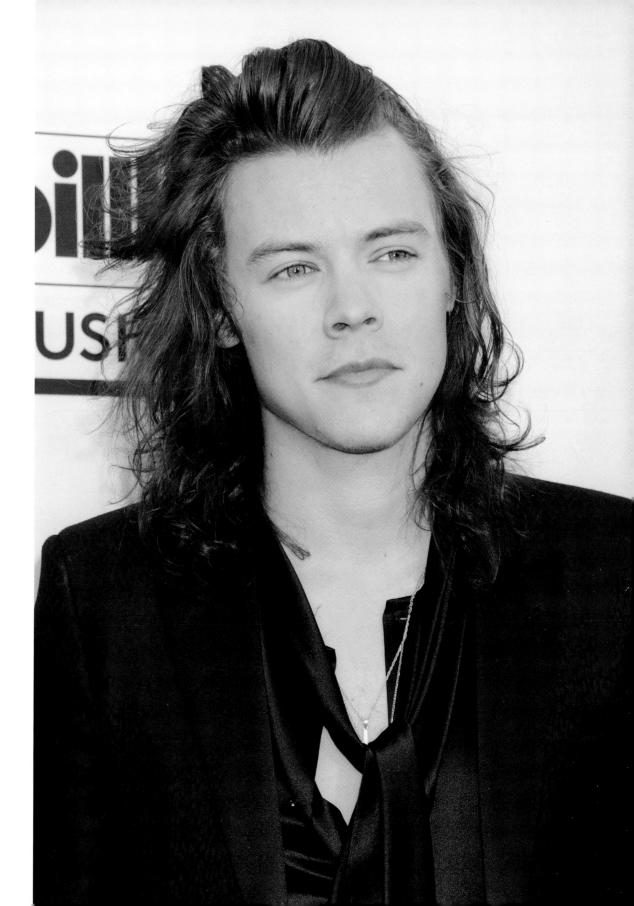

Beat Generation

• •

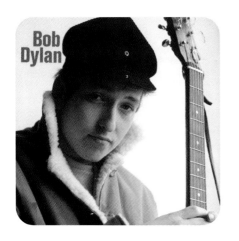

Playing around with appearances is a favourite Harry pastime and his fisherman hat, matched with a rugged brown Balenciaga sweater, moved him into beatnik mid-'60s Bob Dylanesque territory. When Dylan was touring Australia, he was asked by *The Sydney Morning Herald*, 'Why do you wear those outlandish clothes?' Dylan replied that he looked pretty normal where he lived. Styles has the same conviction in his offbeat wardrobe choices and, like Bob, can credibly morph and switch looks.

THIS PAGE: *UK Bob Dylan album cover, from the 1960s.*
OPPOSITE: *Harry Styles performs on NBC's* Today Show Citi Concert Series *in New York City, NY, on 9 May 2017.*

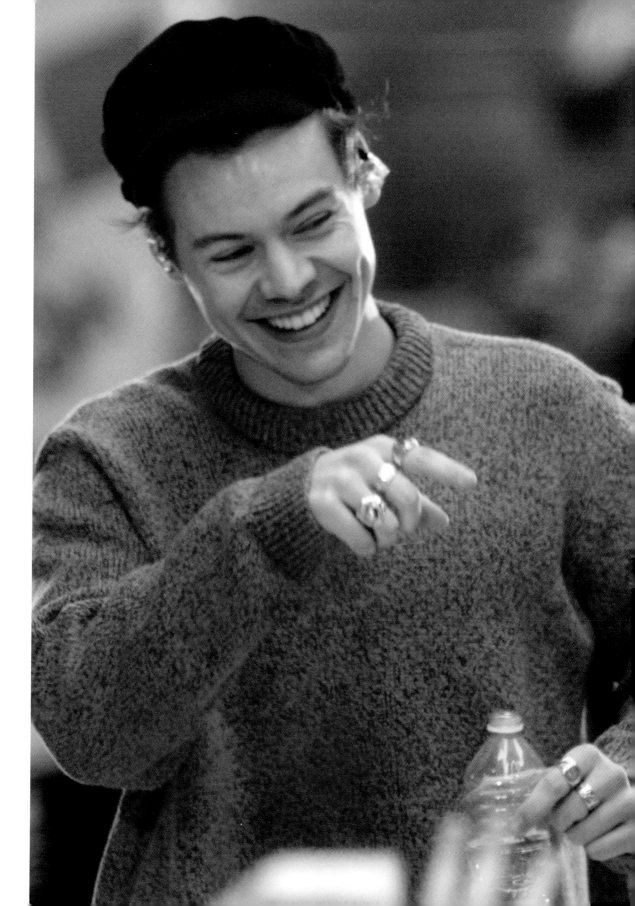

The King and I

· ·

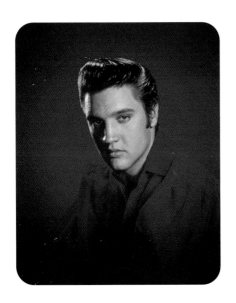

When Christopher Nolan cast Styles in *Dunkirk*, he said it was because 'He has an old-fashioned face ... the kind of face that makes you believe he could have been alive in that period.' On photo-calls for the film, Styles sported a short back-and-sides and a floppy quiff haircut that made him resemble a young Elvis Presley; his features certainly fit the look. Harry Styles' Elvis love is a continuum, and from time to time, with or without a film role in the background, he will dip into the power of a Presley persona. Despite this, Harry didn't mind when he wasn't cast as Elvis in Baz Luhrmann's movie, saying The King 'was such an icon for me growing up. There was something almost sacred about him, almost like I didn't want to touch him.' Just looking like him is fine, instead.

THIS PAGE: *Elvis Presley in 1956.*

OPPOSITE: *Harry Styles attending the photo-call of* Dunkirk *in Dunkerque, France, on 16 July 2017.*

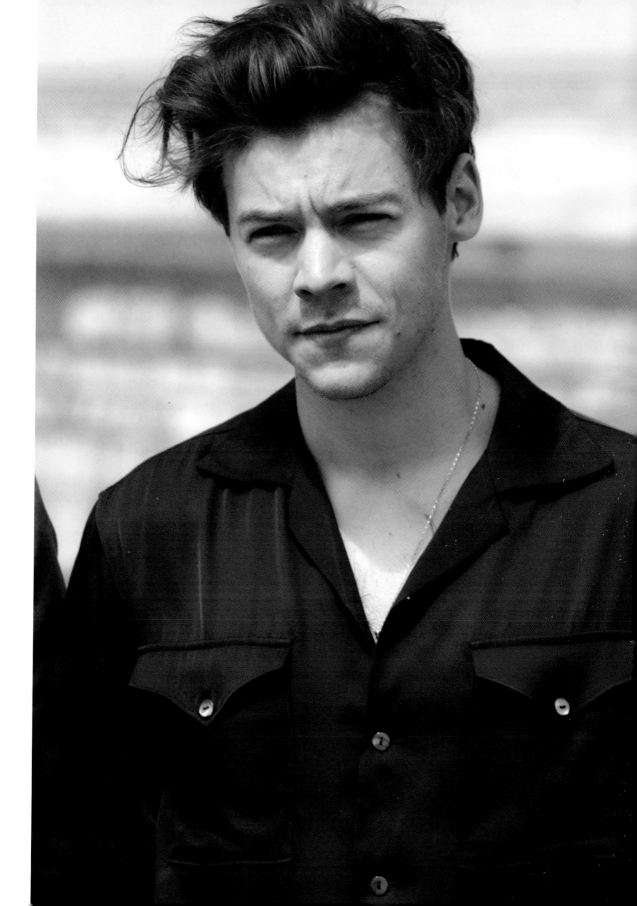

Red Hot

· · · · · · · · · · · · · · · · · · · ·

Harry has made flamboyancy a fashion trend. His colourful clothes and taste for the spectacular has not just engaged legions of fans, but has made it easier for everyone to try something a bit more joyful on for size. This dandy crimson Gucci suit, worn with a black pussy-cat-bow shirt, mixes a flourish of the decadent poet, Charles Baudelaire, with the romance of Elvis. Styles embraced this bold colour scheme once again in 2019, as part of his retro ensemble for *Saturday Night Live*. His suit there was a head-to-toe rendition in red, a testament to his growing fashion consciousness – and confidence.

OPPOSITE: *Harry Styles performs during the CBS Radio fifth annual* We Can Survive *show at the Hollywood Bowl, Los Angeles, CA on 21 October 2017.*

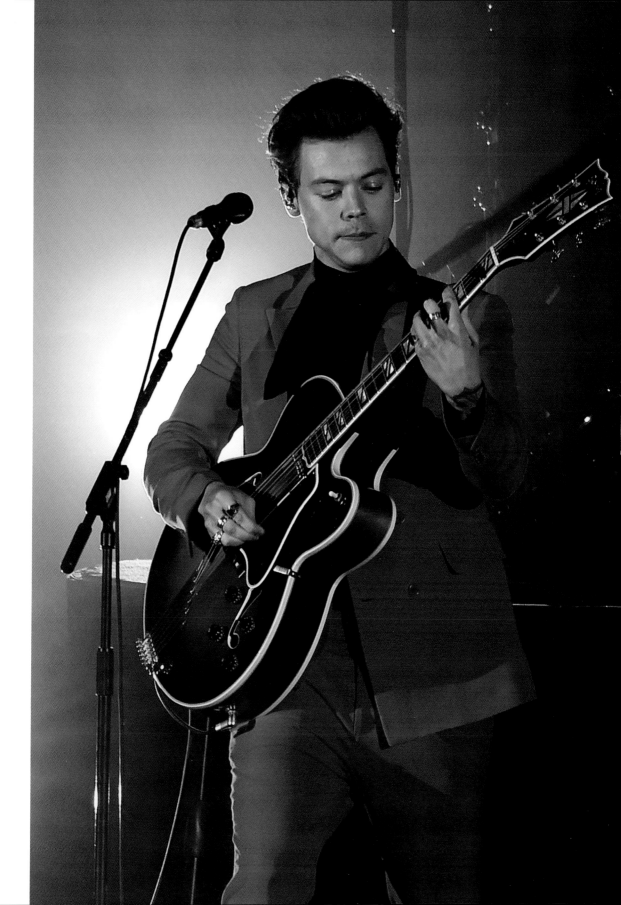

Swanky Threads

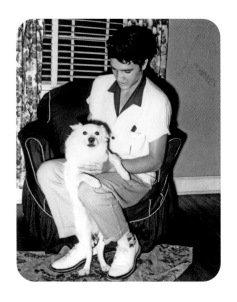

As a celebrity style–hound, Harry is able to secure many catwalk pieces earlier than the rest of the world. In December 2019, he appeared on *The Graham Norton Show* wearing Spring–Summer Marni trousers and a shirt designed by Francesco Risso, who described his camp camo collection as having been inspired by a visit to an imaginary jungle, where the writer Truman Capote might meet – and marry – revolutionary leader Che Guevara. The result was an arty retro-'50s look, which nodded to the gaucho shirts worn by Elvis.

THIS PAGE: *Elvis Presley with family pet at the house he bought for his parents on Audubon Drive in Memphis, TN, circa 1955.*
OPPOSITE: *Harry Styles during the filming for* The Graham Norton Show *at BBC Studioworks, London, UK, Thursday 5 December 2019.*

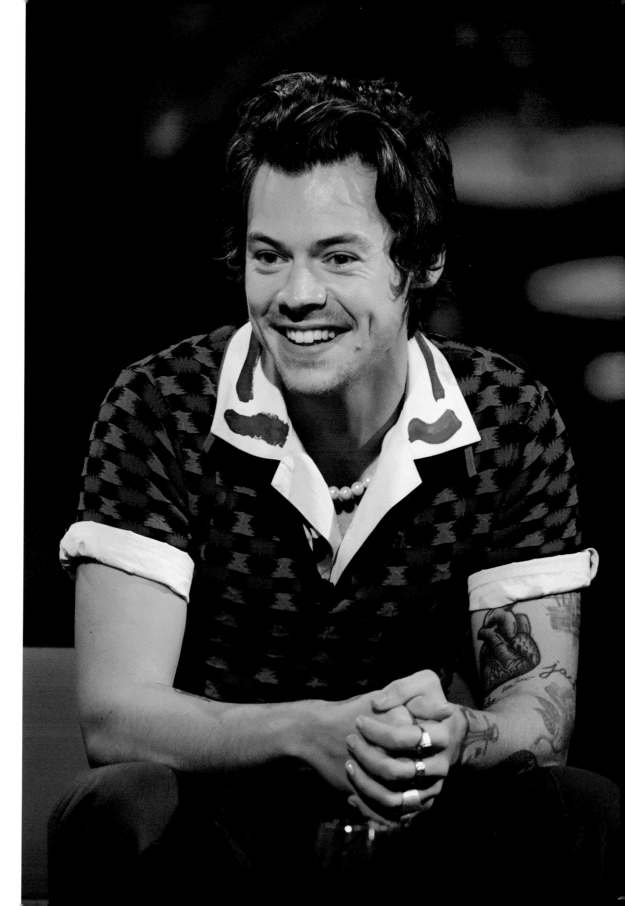

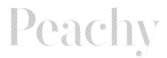

Peachy

The Gucci caramel suit and apricot silk shirt worn for Harry's 2017 Roxy Theatre performance had a vibrant dragon running up the leg and along one sleeve. Without these exotic details, the suit feels much more '80s Armani, with a power-dressing, twinkling turn. True to form, this embroidered embellishment re-focuses the outfit, making the suit an homage to the transformative energy of imperial Chinese symbolism. Powerful stuff.

OPPOSITE: *Harry Styles poses for SiriusXM on 17 May 2017 in West Hollywood, CA.*

'Harry has made flamboyancy
a fashion trend.
His colourful clothes and taste for
the spectacular has not just
engaged legions of fans,
but has made it easier
for everyone
to try something a bit more
joyful on for size. ,

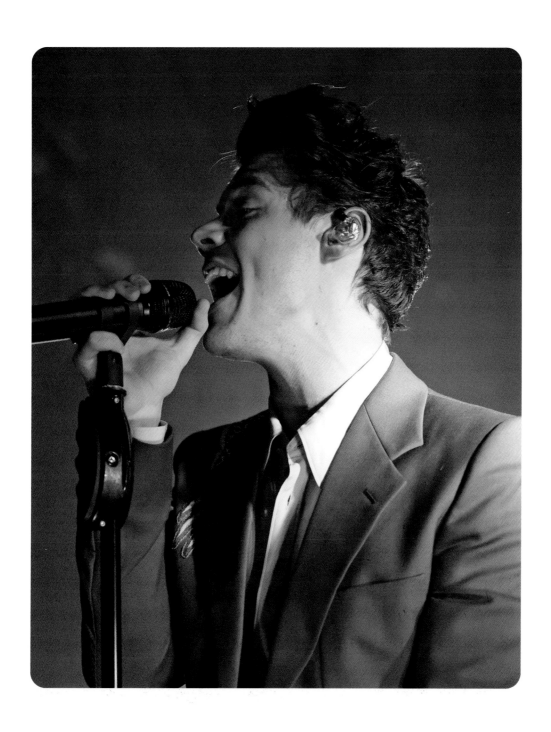

Harry Styles performs for SiriusXM from The Roxy Theatre on 17 May, 2017 in West Hollywood, CA.

Enter the Dragon

· ·

In a lilac haze all of his own making, Harry's love of satin, flares and the colour purple shone when he played a teaser underground gig for his debut solo album in 2017. There was nothing low-key about his outfit, and it set the tone for a year-long Gucci-dressed fest as he sang and danced his way around the world, promoting new songs and showcasing his solo-singer styling.

THIS PAGE: *Guitarist and leader of Led Zeppelin, Jimmy Page, performs at 'A Day on the Green' in the Oakland-Alameda County Coliseum, Oakland, California, 23 July 1977.*
OPPOSITE: *Harry Styles leaving a secret gig at the Garage in Islington on 13 May, 2017 in London, UK.*

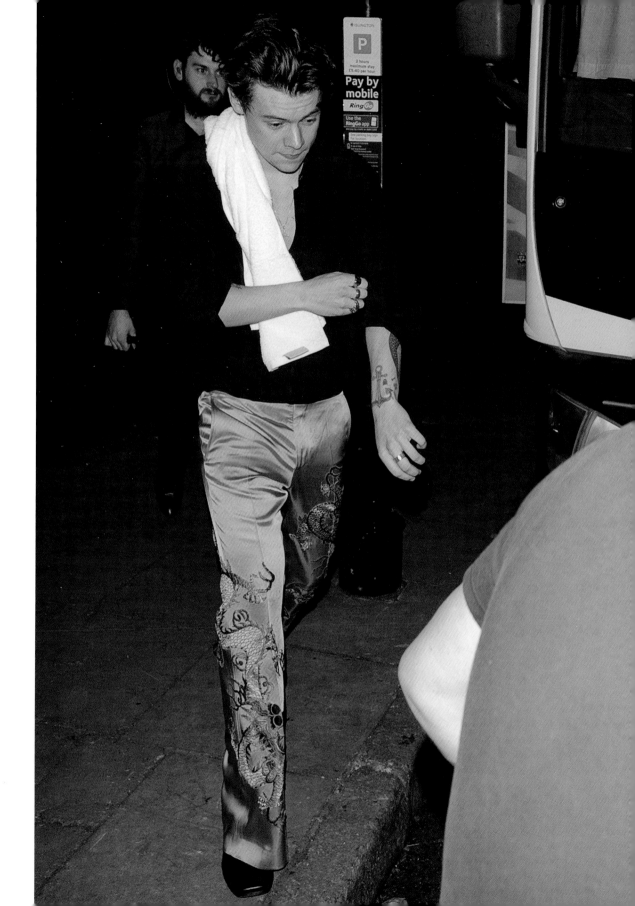

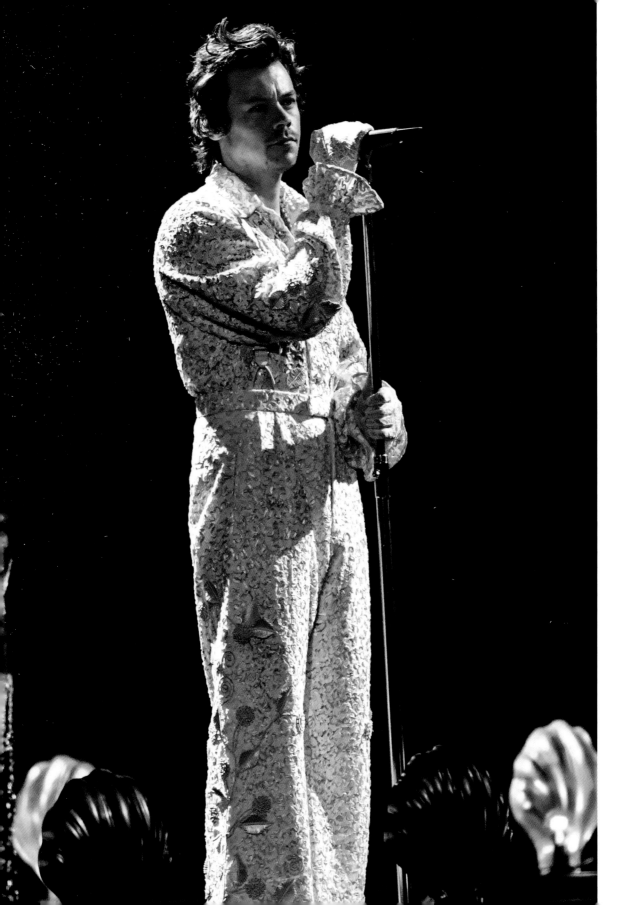

Love Lace

Rich men and military officials often wore lace collars and cuffs in 17th- and 18th-century Europe. Fast-forward to the '70s, and men in lace disco shirts strutted their stuff under sparkling dance-floor glitterballs. Poptastic Prince made lace his own in the '80s, wearing signature frilled shirts, unbuttoned and unravelled, all with a super-sexy attitude. When Harry wore his high-waisted lace Gucci trousers, matching shirt and gloves at the BRIT Awards in 2020, it seemed like a brave fashion first – though in truth, it was the revival of a classic.

' My clothes are not kept in a **refrigerated vault.** ,
—Harry Styles, Hits Radio, 31 October 2019.

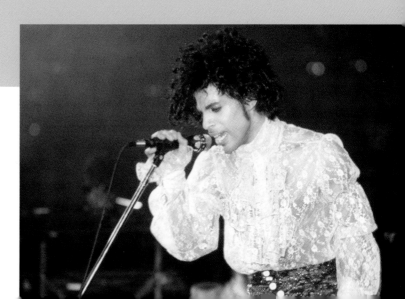

THIS PAGE: *Prince performs onstage during the Purple Rain Tour, at the Joe Louis Arena in Detroit, MI, on 4 November 1984.*
OPPOSITE: *Harry Styles on stage at the BRIT Awards 2020, at the O2 Arena, London, Tuesday 18 February 2020.*

Pin-sharp

· ·

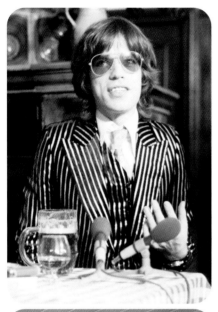

The heritage of a British pinstripe suit threads back most famously to Savile Row, where a bespoke approach to city gent–wear was and still is imperative. When a rock–and–roll star dons this classic office uniform, the resultant juxtaposition of effect comes across as transgressive and cool. Both Elton John and Mick Jagger knew how compelling the pinstripe could be in the '60s and '70s, so it's no accident that when Harry was invited to the British Fashion Awards in 2014, he chose to wear a black–and–red striped Lanvin number. He pinstriped up again to attend the Glam Rock Christmas Party at The Scotch social club in St James's – combined with his long, wavy hair, this choice of suit sent a stylish sartorial message.

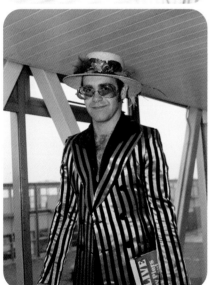

THIS PAGE TOP: *Mick Jagger of The Rolling Stones wearing a striped suit in 1973.*
THIS PAGE BOTTOM: *Elton John wearing a hat trimmed with flowers and feathers, arriving at Heathrow from Los Angeles, 30 August 1974.*
OPPOSITE: *Harry Styles arriving at the British Fashion Awards 2014, London, UK.*

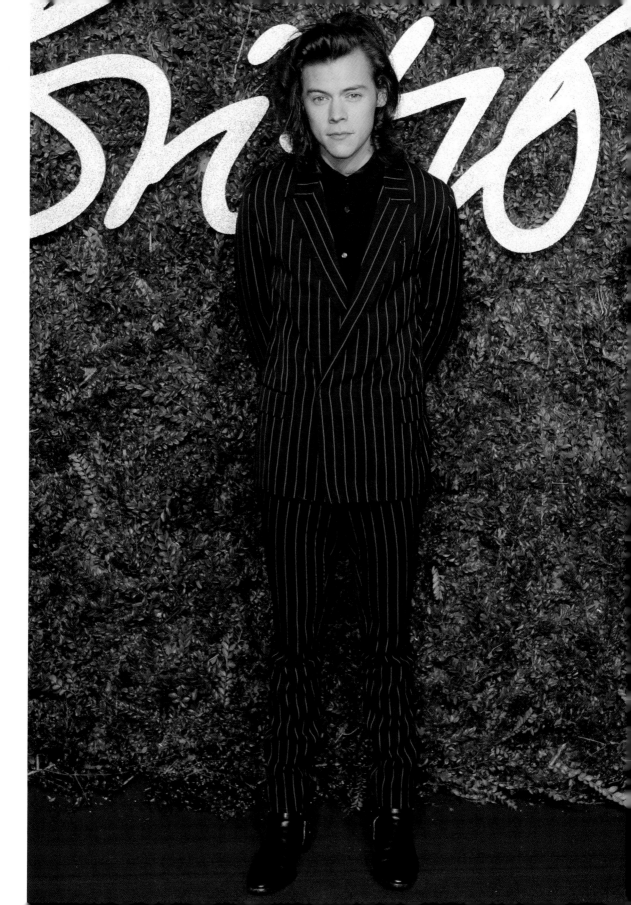

' The heritage of a British pinstripe
suit threads back most famously
to Savile Row, where a
bespoke approach to
city gent–wear was and
still is imperative.
When a rock–and–roll star dons this
classic office uniform,
the resultant juxtaposition
of effect comes across
as transgressive
and cool. ,

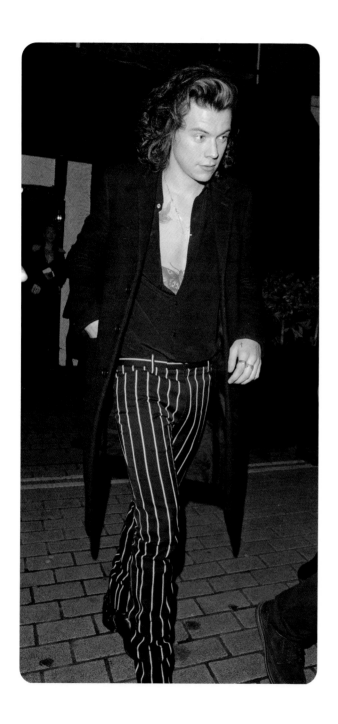

Harry Styles attends the Glam Rock Christmas Party to celebrate the collaboration between House of Hackney and Terry De Havilland at The Scotch of St James's, London, UK. on 11 December 2014.

Jump for my Love

From Schiaparelli to Balenciaga, the biggest names in fashion have taken the jumpsuit and made it their own. Geoffrey Beene, the great American designer known for his simple but glamourous take on athleisure, was an especially huge fan, recognising the jumpsuit's potential as a practical solution for day–to–evening wear. The jumpsuit is a wardrobe classic suitable onstage as well as off – as proven when Harry wore a Charles Jeffrey pinstripe version on *The Late Late Show with James Cordon*, for his performance of 'Kiwi' from his debut solo album. He made the jumpsuit sharper than ever.

'Jumpsuits are the ballgown of the next century. '

—Geoffrey Beene, *Geoffrey Beene Unbound*,
Museum at the Fashion Institute of Technology, New York City, 1994.

OPPOSITE: *Harry Styles performs on* The Late Late Show with James Corden, *Thursday 18 May 2017.*

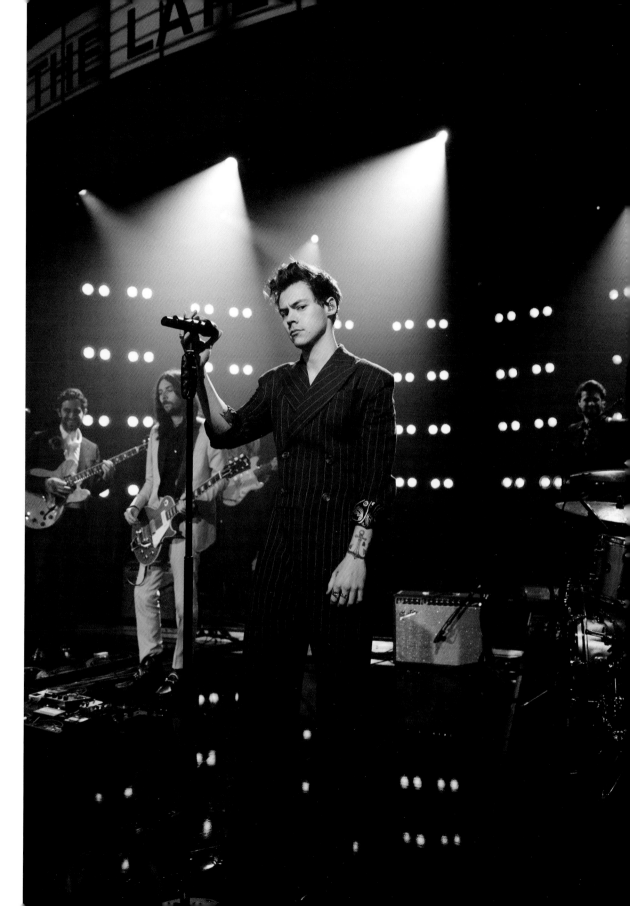

Front-Row Face

Continuing his fashion education, Styles attended London Fashion Week in 2014, gracing the front row at Burberry's Autumn/Winter show. It's always difficult to know how to dress when you're in the fashion spotlight, but Harry held his own alongside fellow "FROW-ers" Anna Wintour, Bradley Cooper and Naomie Harris, as he sported a bottle-green suede Burberry trenchcoat. Burberry at the time was the hottest ticket in town, and designer Christopher Bailey's collection was stronger than ever – it's no wonder that Harry had shown his support for the label the previous season too.

OPPOSITE: *Harry Styles attends the front row at Burberry Womenswear Autumn/Winter 2014 at Kensington Gardens on 17 February 2014 in London, UK.*

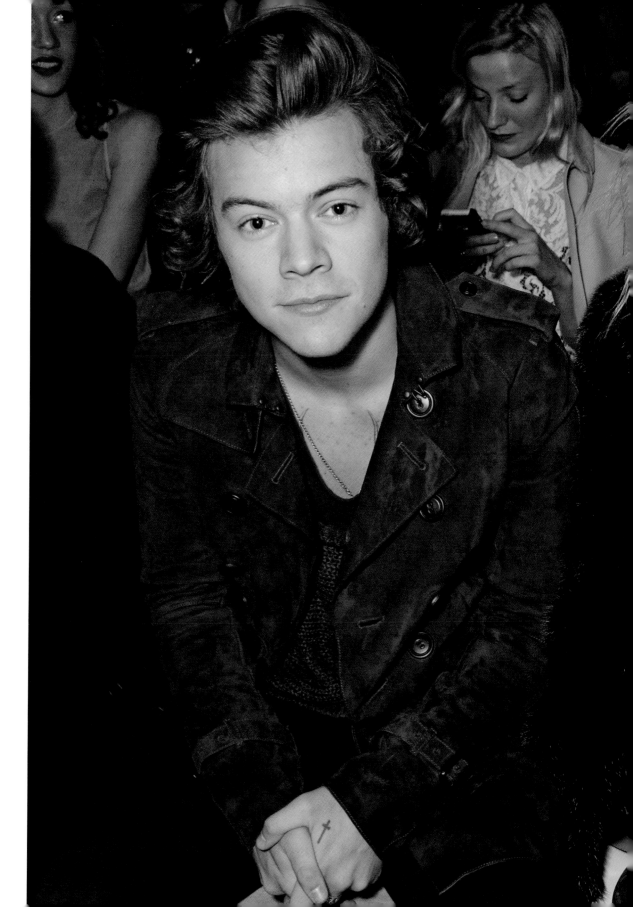

The Emperor's New Clothes

· ·

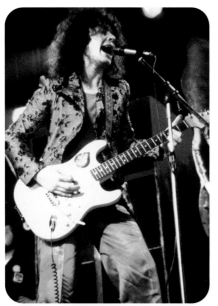

An ancient and revered class of fabric, brocade is a fine example of what to wear if you want to dress to impress. Over the centuries, it has been used ceremonially by dynastic leaders, royals, aristocrats and military folk, and its splendour has not been lost on the sovereigns of rock and roll. Megastars including Marc Bolan and Prince have used the cloth to clothe themselves while strutting their stuff onstage. Harry joined their ranks in a woven red–and–black Gucci suit as part of his debut solo 2017 tour. This snazzy suit acted as his armour when he stepped into the limelight at the Radio City gig and announced, 'Hello, I'm Harry from London [...] I've only got 10 songs'.

THIS PAGE TOP: *Marc Bolan, circa 1971.*
THIS PAGE BOTTOM: *Prince performs onstage at the Joe Louis Arena in Detroit, MI, during the Purple Rain Tour on 4 November 1984.*
OPPOSITE: *Harry Styles performs onstage at Radio City Music Hall on 28 September 2017 in New York City, NY.*

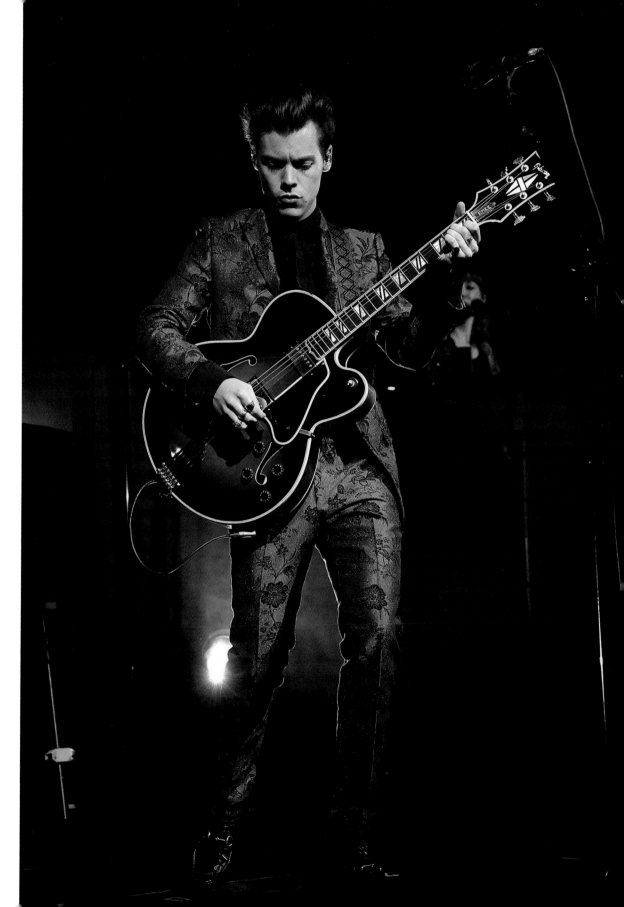

Purple Rain

The dandification of rock and roll wouldn't be complete without mentioning Prince, the 'Paisley Park' royal, whose affection for this stunning ornamental pattern influenced his sartorial choices as well as his songwriting. Harry and Prince are kindred spirits; both have held the baton for beautiful, androgynous fashion fluidity. The mere idea of wearing a shiny mauve suit is a step out of most folks' comfort zones – yet, just as Prince moved the goalposts of the masculine wardrobe while touring his *Purple Rain* album in the '80s, so too did Harry bring purple paisley into the 21st century.

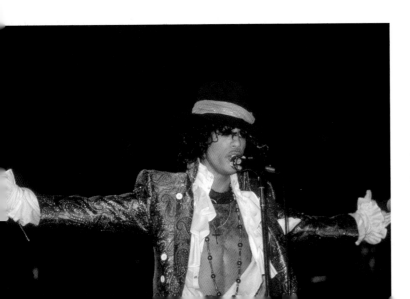

THIS PAGE: *Prince performs at the Joe Louis Arena in Detroit, MI, during the Purple Rain Tour on 12 November 1984.*
OPPOSITE: *Harry Styles performs during the 31st Annual ARIA Music Awards 2017 at The Star, Sydney, Australia on 28 November 2017.*

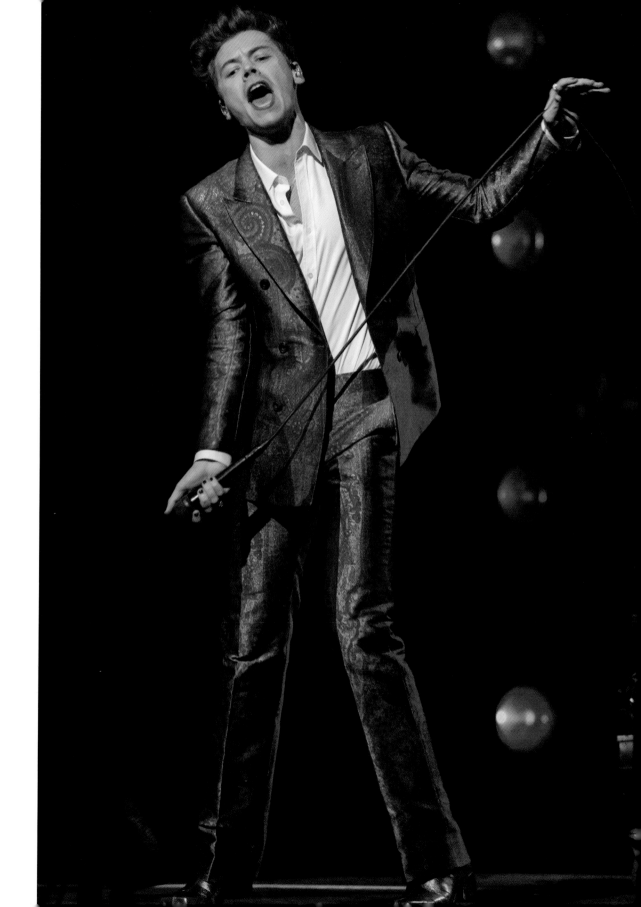

Double-Trouble

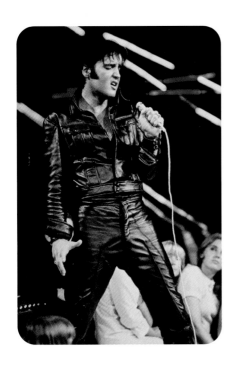

Double anything is a sizable sartorial statement to make. Duple or even thruple denim runs the risk of dating fashion declarations to the '90s, but in reality, if you have poise, this isn't a difficult look to pull off. Elvis paired black leather trousers with a black leather top when he filmed his NBC comeback show in 1968. He sweat till he shone, giving his all after seven years spent far away from the microphone, performing in films. In 2019, Harry adopted a sparkly twinset of denim pants and a jacket from talented young Spanish designer Archie Alled-Martínez. He stripped to the waist, baring his butterfly tattoo, and showed us how much he glistened, too.

THIS PAGE: *Elvis on his NBC TV Comeback Special, filmed in Burbank, CA, June 1968.*
OPPOSITE: *Harry Styles performs onstage during day one of Capital's Jingle Bell Ball at London's O2 Arena, December 2019.*

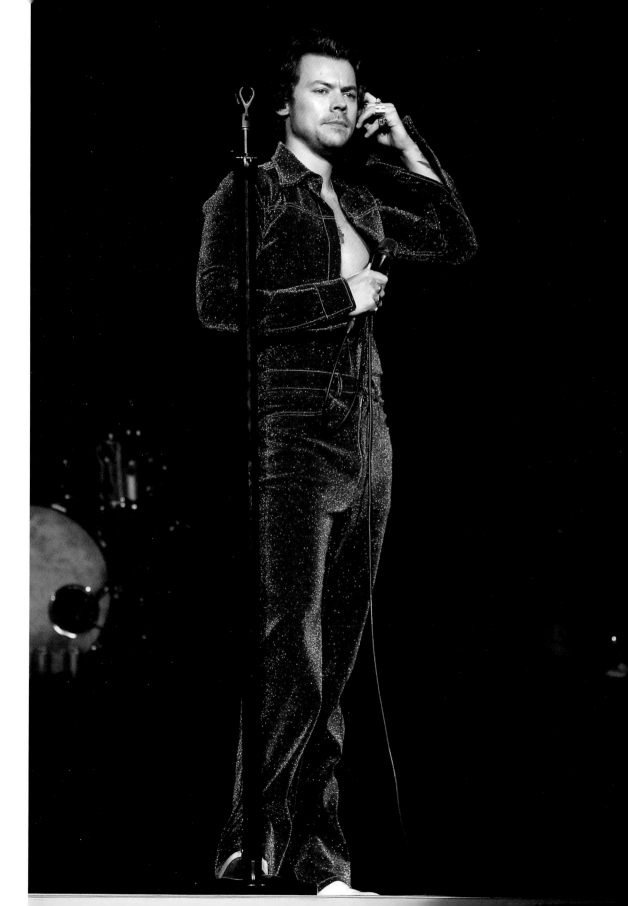

Checkmate

Arriving at the studio to co-host the December 2019 *Late Late Show with James Cordon* and play 'Spill Your Guts' with Kendall Jenner, Harry decided to shrug on a tartan Lanvin overcoat. Plaid is the pattern of winter and along with his multi-tinted manicure – considered classically Styles by 2019 – Harry looked holiday ready. It was a cosy choice: the coat was part of the debut collection designed by Bruno Sialelli for Lanvin's Autumn/Winter collection, 2019. Similarly, in 2017 he chose a simple, nerdy, just-on-the-right-side-of-classy check Gucci suit to sing 'Sign of the Times' on *Saturday Night Live*. Later that year, he celebrated his debut solo album wearing a cherry-and-white check Vivienne Westwood two-piece.

OPPOSITE: *Harry Styles performs in 'Crosswalk Concert' on* The Late Late Show with James Corden, *airing Wednesday, 11 December 2019.*

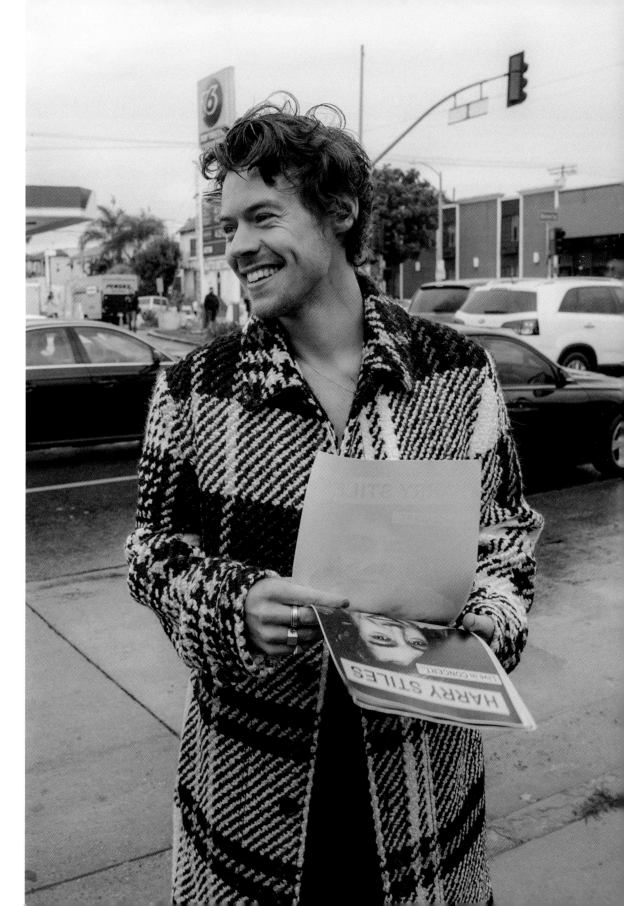

'You can never be overdressed.
There's no such thing. '
Vogue magazine, 2020.

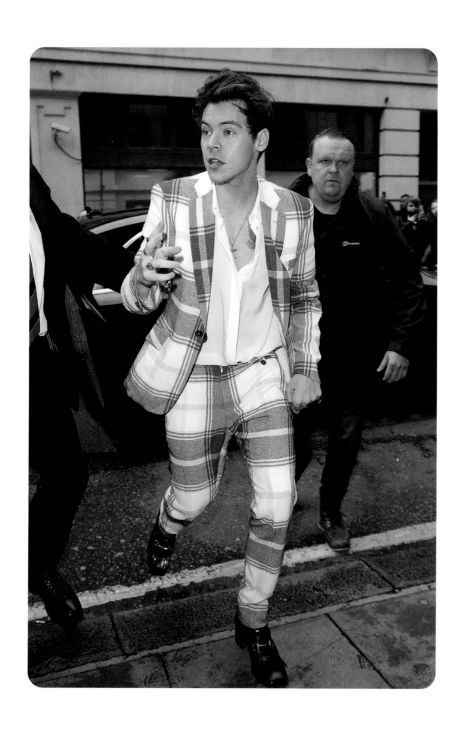

Harry Styles at BBC Radio 2 Studios, London, UK, promoting his new album on 12 May 2017.

Rocket Fan

Elton John played the Dodger Stadium in spectacular style in 1975, wearing a sequinned baseball outfit created by the 'Rajah of the Rhinestones', Bob Mackie. The American designer said in a *Vogue* interview that Elton wanted the sort of thing Mackie had previously created for sparkling superstar Cher – but while Elton drew inspiration from the Goddess of Pop, he himself went on to inspire countless others with his own fashion fabulousness, including Alessandro Michele, who conceived his Spring/Summer 2018 Gucci collection in homage to the intergalactic Rocketman. Meanwhile, Harry, Alessandro's muse, is a massive Elton fan. In a bizarre twist, he had a replica Dodgers' kit made for a Halloween party that took place on 26 October … the same date Elton sang to the stadium, back in '75!

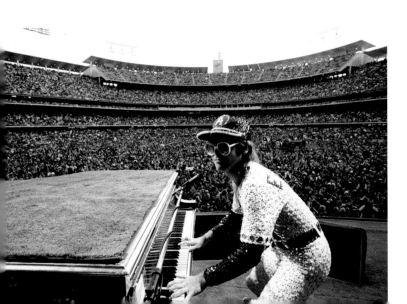

THIS PAGE: *Elton John performing at Dodger Stadium in Los Angeles, 1975.*
OPPOSITE: *Harry Styles attends the Casamigos Halloween Party on 26 October 2018 in Beverly Hills, CA.*

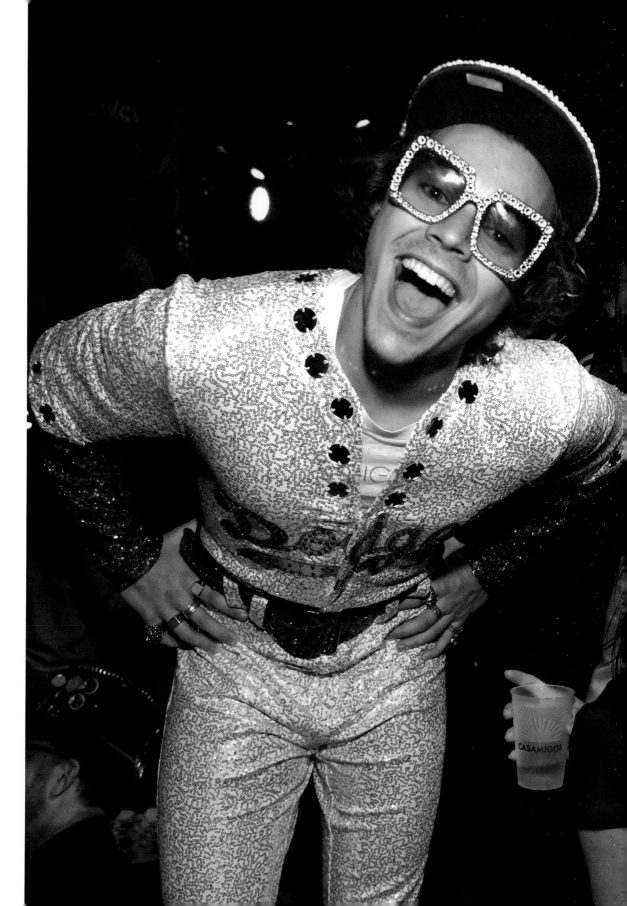

Saying it with Flowers

' Isn't it weird to think five or six years ago, something like that could cause such a stir? ,
—Harry Lambert, *Coveteur*, 2021.

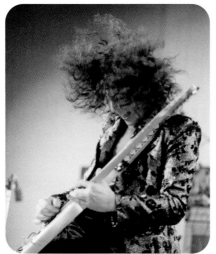

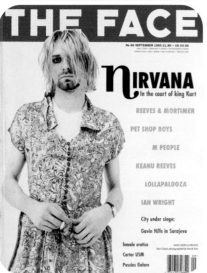

When Harry Lambert gave Harry Styles a monochrome Gucci suit covered in flowers to wear in 2015, it marked the blossoming of a beautiful relationship. The Harrys share a mutual love of floral wardrobe fun, mostly courtesy of Gucci. Flowers and music go hand-in-hand: in the 1960s, The Beatles spread the love of hippified psychedelic blooms. Marc Bolan satinised flowers in the glam '70s, and by the '90s, Kurt Cobain was wearing outsider-chic floral dresses, provoking mainstream sensibilities and broadcasting genderflux messages in every direction. Still, when Styles first wore Gucci florals, the world went crazy – even his kinder critics called it a 'bold move'. Harry himself told Nick Grimshaw in 2017 that the fabled black–and–white Gucci suit was not one of his greatest looks – but it's grown on the rest of the world (or perhaps, the rest of the world has grown to fit it). Now, florals are a joyful Harry staple. Nowadays, when Styles struts out in flower print, folk think he looks blooming marvellous.

THIS PAGE TOP: *Marc Bolan performing with English glam rock group T-Rex at the Empire Pool, Wembley (now Wembley Arena), London, UK, 20 March 1972.*

THIS PAGE BOTTOM: *Kurt Cobain,* The Face *magazine, September 1993.*

OPPOSITE: *Styles arrives at the 2015 American Music Awards at Microsoft Theater on 22 November 2015 in Los Angeles, CA.*

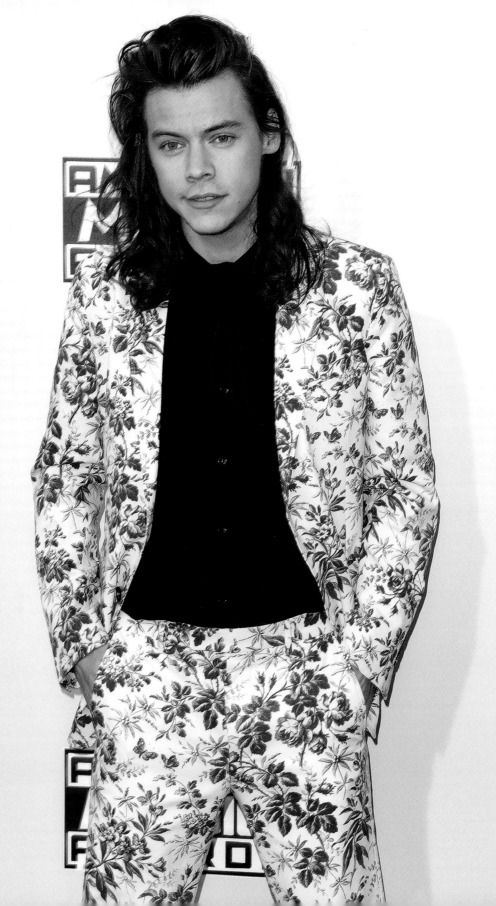

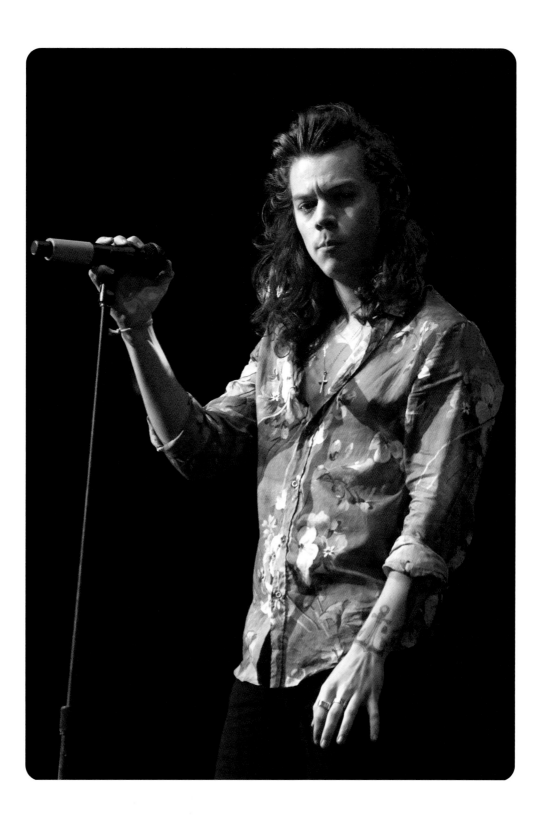

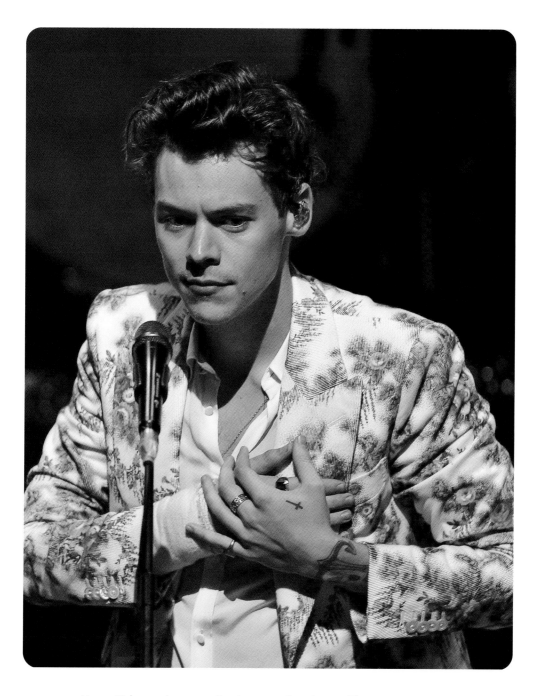

THIS PAGE: *Harry Styles performs on the tour opening date at The Masonic on 19 September 2017 in San Francisco, CA.*
OPPOSITE: *Styles performs during the 6th Annual 99.7 NOW! Triple Ho Show at SAP Center on 2 December 2015 in San Jose, CA.*

Advertising Guru

To date Harry has starred in five Gucci campaigns, most recently for the 100-year anniversary of the house. During their Beloved bags publicity drive, an entire show, fronted by James Cordon, was commandeered for the cause. Guests walked with and talked about their favourite Gucci bags. Harry's was a Jackie 1961 shoulder-strapped number. As a Gucci Face, photographs of him cuddling goats, pigs, hens and dogs or eating in chip shops – all while wearing divine tailoring and cruise-wear – have ricocheted around the digi-sphere. The juxtaposition of a wacky wardrobe and a mini farmyard seems to work well as a fashion formula.

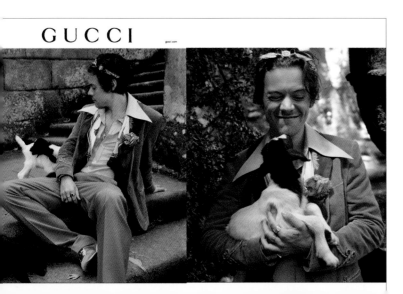

THIS PAGE: *Gucci Cruise 2018, shot by Glenn Luchford.*
OPPOSITE: *The second campaign of Gucci Cruise 2018.*

GUCCI

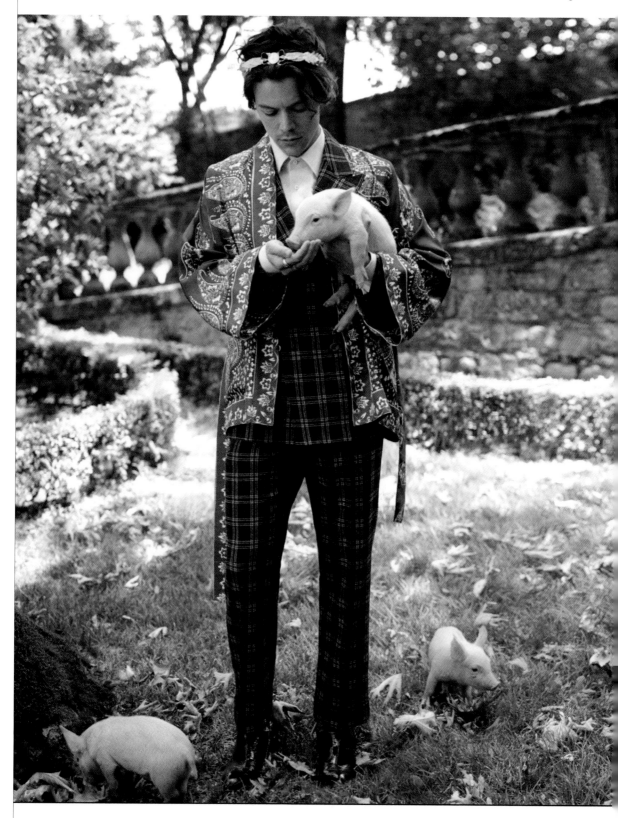

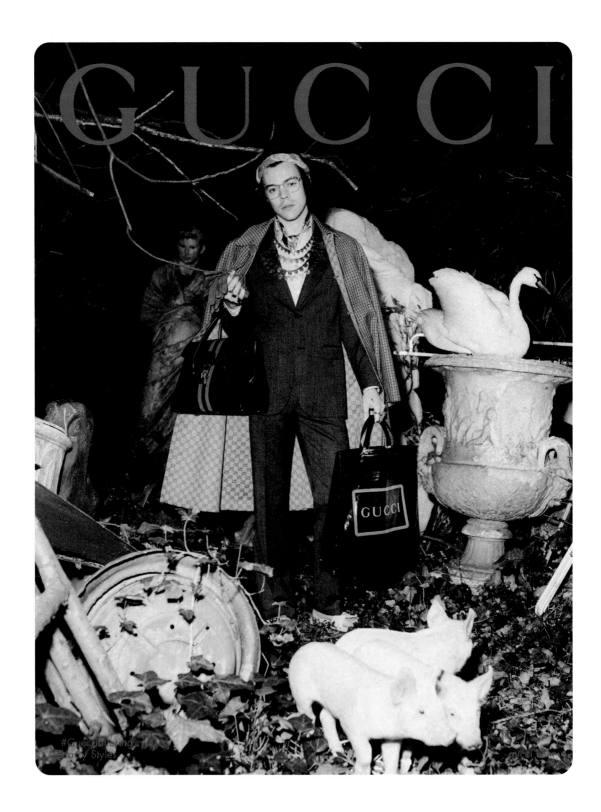

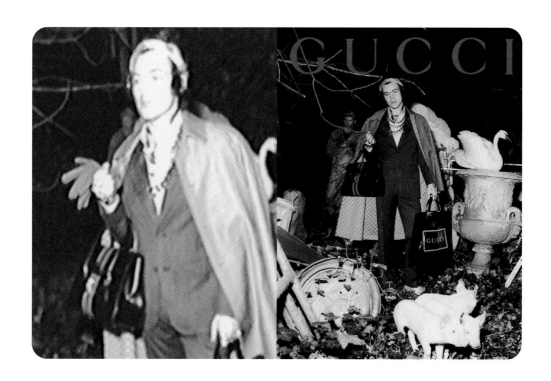

THIS PAGE AND OPPOSITE: *Gucci pre-fall 2019 collection, third campaign.*

Jazzy Court Jester

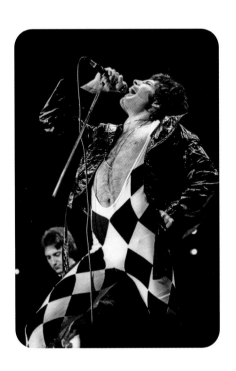

In 2017, Harry played his debut solo tour and sealed a deal to exclusively wear Gucci for the first year. This was a win for both parties: Styles looked amazing every minute, and Alessandro got to dress his favourite singer. One of the stand-out outfits was a harlequin flared trouser suit in black and red velvet, finely enhanced with an all-over double-G logo and inspired by the traditional Harlequin character from Italian Commedia dell'arte – the original forefather of what's become a fun fashion motif. The look stood testimony to how far Harry's fashion sense had evolved; the suit was a statement but looked smooth and modern. It was a retro-'70s silhouette, fathomed in 21st-century style. Rock god Freddie Mercury very famously made the Harlequin print his own and his impish legendary wardrobe included many variations, including plunge-necked, skin-tight cat-suits that make Styles' version look impressively understated.

THIS PAGE: Freddie Mercury fronting rock band Queen on stage at the Richfield Coliseum, Ohio, 23 January 1977.
OPPOSITE: Harry Styles performs onstage during the iHeartRadio Music Festival at T-Mobile Arena on 22 September 2017 in Las Vegas, NV.

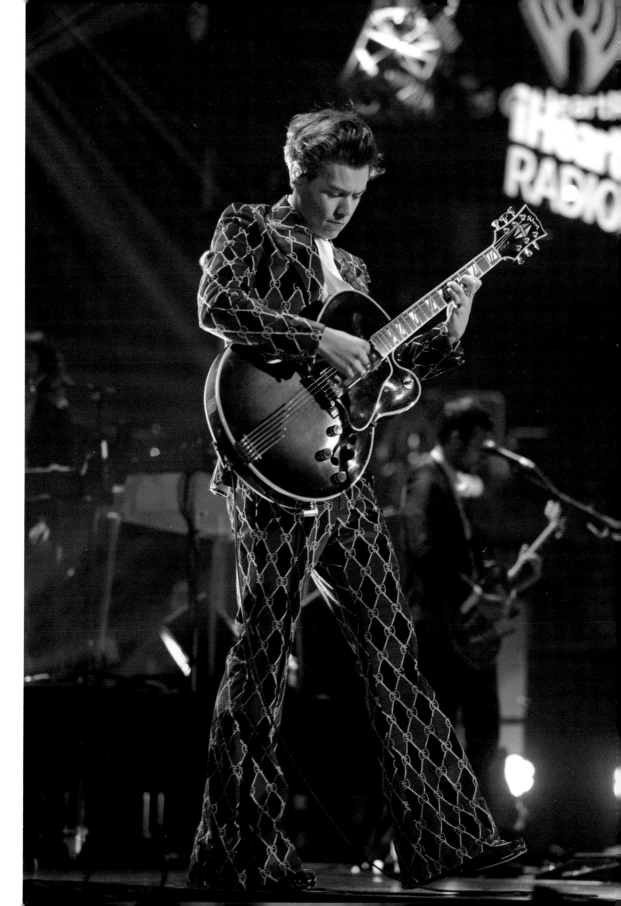

No-Sweat

On stage and off, Harry sports Gucci. Formal or informal, he makes this label work for him. In this case, an old-school, logo'd Dapper-Dan-like sweatshirt makes for a label-tastic athleisure classic to pose in. While a casual, candid airport-look, this outfit shows both Styles' commitment to representing Gucci and his ability to dress-down while still maintaining an aura of fashion-forward chic. The matching suede jacket and tan boots are the perfect accents to offset his black sweater and skinny-jeans combo, and Styles completes the look by substituting a hairband for shades. Effortlessly cool, comfortable, and ultra-contemporary – we love to see it.

OPPOSITE: *Harry Styles arrives at Gare du Nord station on 26 April 2017 in Paris, France.*

Aloha

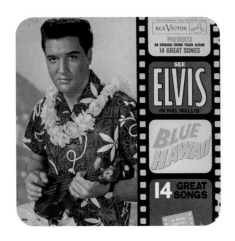

Bold, brash and esoterically collectible, the world of Hawaiian shirts is one in which only the cultiest vintage clothes dealers dare dabble. That said, Hedi Slimane's version from the Spring/Summer 2016 Saint Laurent collection, the catchphrase of which was 'a tribute to contemporary Californian surf music culture', has a credibility only this high-flying designer can confer. Harry's favourite new-retro shirt, worn regularly throughout his long-hair phase, hails from that now-classic season.

THIS PAGE: *Elvis's vinyl LP cover for the* Blue Hawaii *film soundtrack.*
OPPOSITE: *Harry Styles leaving after shopping at Saint Laurent, Beverly Hills, CA, 2 February 2016.*

King Pin

As a bowling shirt buff, Harry has revealed just how much he knows his way around the retro-inspired wardrobe. Worn by 1950s cool-cats, including Johnny Cash and Buddy Holly, the bowling shirt is a leisurewear piece that signals a step-up from 'T-shirt casual'. Originally more of a dad-fad, now bowling shirts are favourite additions to catwalk collections from Prada to Balenciaga – but personalised versions like Harry's really bowl us over.

OPPOSITE: *Harry Styles arrives at 102.7 KIIS FM's Jingle Ball at the Staples Center in Los Angeles, CA on 4 December 2015.*

My Generation

Sonny and Cher suffered for their style – when they strode into German fashion circles, their matching supermod check–pattern suits saw hotels and restaurants refuse admission. Styles, thankfully, has enjoyed a sunnier reception. Op–Art in fashion dates back to the 1960s, when geometric arrangements were used on ties by Paco Rabanne and miniskirts by Mary Quant. The Art Deco decoration is something of a mod classic too, and Harry's brown–patterned Gucci suit and Cuban heels are a salute to this subcultural style.

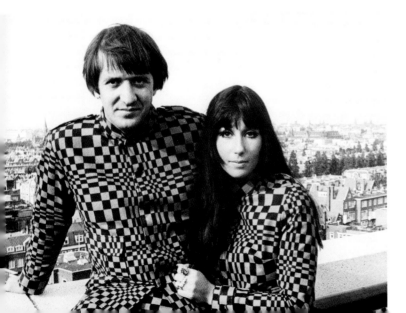

THIS PAGE: *Sonny and Cher in matching supermod suits.*
OPPOSITE: *Harry at the* LOVE *magazine party, held at Loulou's, London, 22 September 2015.*

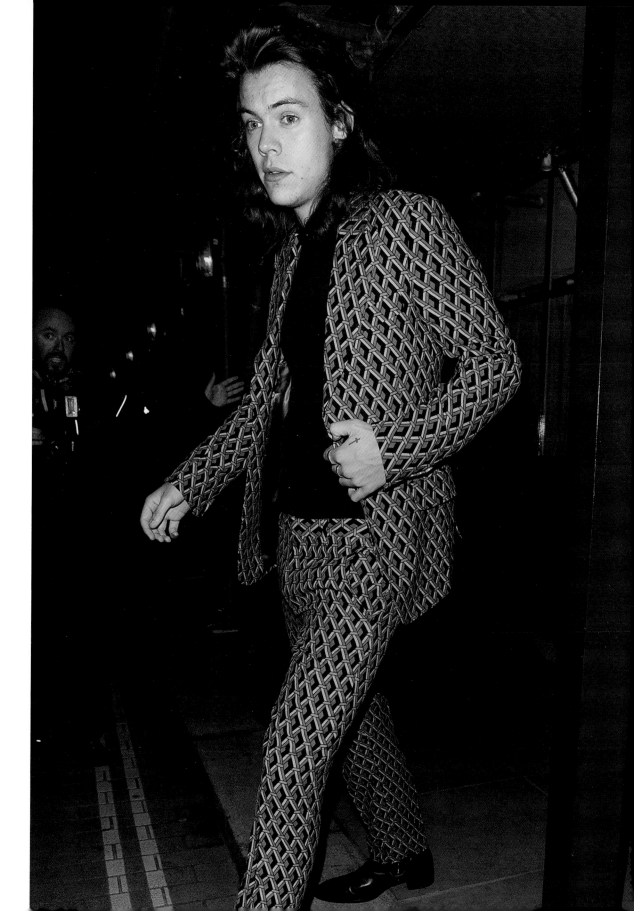

HashtagHarryStylesCardigan

· ·

'I am so impressed and incredibly humbled by this trend
and everyone knitting the cardigan.
I really wanted to show our appreciation, so we are
sharing the pattern with everyone. Keep it up! ,
—Jonathan Anderson, July 2020

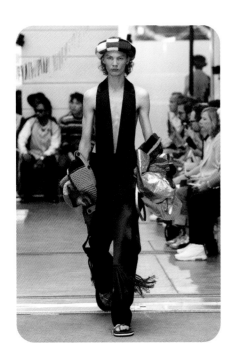

Harry is no stranger to virality – but there's going viral, and there's *going viral on TikTok*. Harry's J. W. Anderson cardigan hit the stratosphere after he wore it to *The Today Show* rehearsals in February 2020. The planets aligned as, in the midst of a global pandemic, stay-at-home fans grabbed their knitting needles and took on the Harry-cardi challenge. Jonathan Anderson kept the game alive longer by publishing on his website an actual pattern for the iconic knitwear piece. The fun was in the fact you could have, as fans on TikTok realised, nada knitting skills and still create at home something the V&A christened 'a cultural phenomenon'. When the Harry-cardi hashtag accumulated 40.1 million hits, the museum swooped to crystallise the moment, placing the J.W. Anderson piece in their permanent collection.

THIS PAGE: *A model walks the runway at the J. W. Anderson show during Paris Men's Fashion Week Spring/Summer, 19 June 2019.*
OPPOSITE: *Harry Styles pictured during a rehearsal performance at the* Today Show, *in Uptown, Manhattan, New York, 2020.*

'The last time Harry performed
for *The Today Show*,
the images from that
rehearsal were seen a lot,
so we wanted to have
something fun for this one.
This cardigan has
so much character,
something that you could have found
in your parents' closet from the '70s;
it felt perfect for Harry. ,

Harry Lambert, *Vogue*, July 2020

'When the Harry–cardi hashtag accumulated 40.1 million hits, the V&A swooped to crystallise the moment, placing the J. W. Anderson piece in their permanent collection. ,

Nailing it

· ·

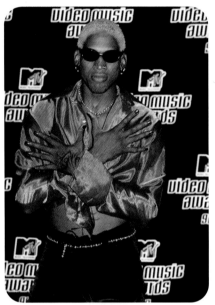

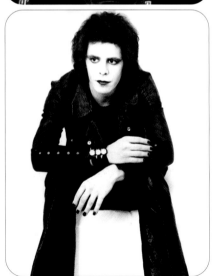

Nail varnish is a fashion flourish that Harry has made his own. He follows in the path of boys who polished their pinkies in the past, including athlete Dennis Rodman, who busted out the bottle-green sparkling varnish at the MTV Awards in 1996. The 6'7" basketball hero painted his nails to complement his bleached blond hair. Lou Reed is another mega-god in the world of looking good, known for minding his manicure. The Velvet Underground was a band that did not trouble themselves with convention: as part of Andy Warhol's Factory gang, they were used to dressing decadently and living large. Nice nails were normal for Reed; entry level grooming, in fact. And it's an obvious Harry habit, too – so much so that in November 2021, Hazza launched his own range of varnishes under his inclusive beauty line, Pleasing.

THIS PAGE TOP: *Dennis Rodman at the 13th Annual MTV Video Music Awards, held at Radio City Music Hall in New York City, NY, 4 September 1996.*
THIS PAGE BOTTOM: *Lou Reed, circa 1973.*
OPPOSITE: *Detail of Harry Styles' nails and rings, while backstage in the on-air studio during day one of Capital's Jingle Bell Ball, London's O2 Arena, December 2019.*

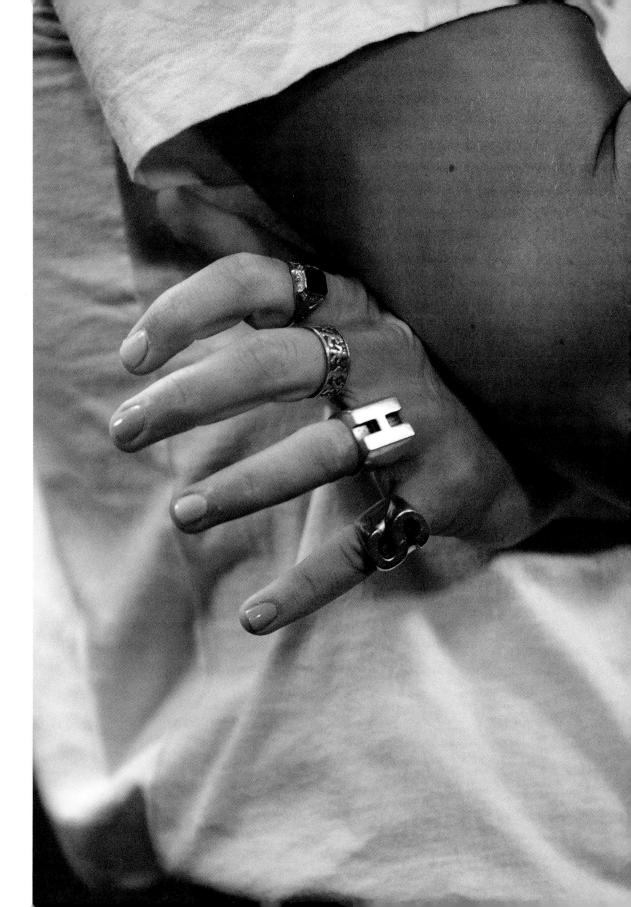

Ring Bling

Conspiracy theories surrounding the significance of Harry's favourite rings have flourished on social media, especially as he's been wearing a stainless steel 'peace' band on his right middle finger on and off since 2013. Superfans who know Harry well are savvy enough to recognise that his jewellery wardrobe – like his fashion sense – is a bit of a playground. One fact is for sure: Harry adores adornments. Even among his considerable collection, the antique micro–mosaic Georgian digit–dazzler featuring a Goldfinch, which he wore at The BRITs in 2021, is serious treasure.

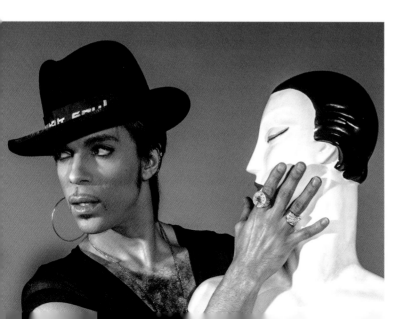

THIS PAGE: *American recording artist Prince Rogers Nelson, better known as just Prince wearing costume gold and diamond signet rings. Shot by Steve Parke.*
OPPOSITE: *Close up of Harry's rings as he arrives on the red carpet at the Dunkirk New York Premiere in New York City, NY, on 18 July 2017.*

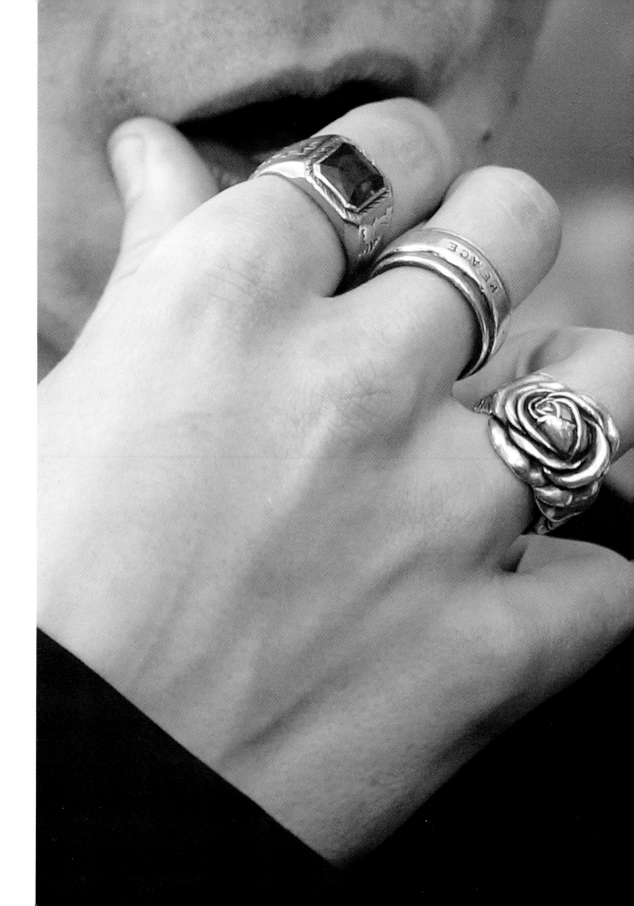

Join the Dots

· ·

The unforgettable Spring/Summer 2016 menswear Saint Laurent Collection featured models wearing blousy oversized shirts and bug-eyed white Cobain shades. Harry was spotted sporting many of that season's catwalk looks, including this bubblegum polka-dot top. He wore it unbuttoned while onstage with One Direction, the sleeves rolled up to show off his tattoos – tickling everyone in the audience a stylish shade of pink.

OPPOSITE: *Harry Styles of One Direction performs on stage as part of Apple Music Festival at The Roundhouse, London, UK, on 22 September 2015.*

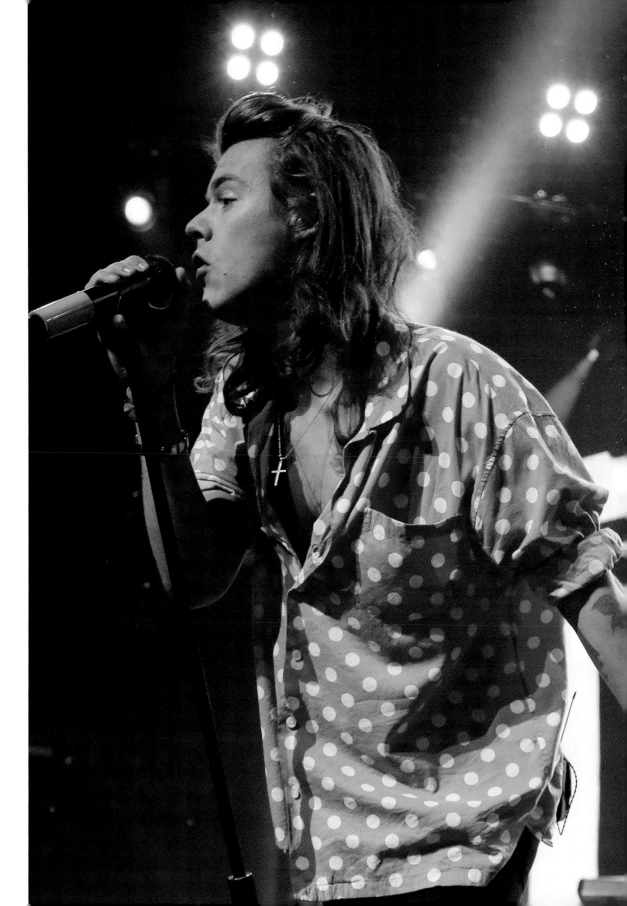

Accidently Wes Anderson

Looking very 'accidently Wes Anderson' on the *Today Show* in 2020, Harry's rock-out performance contrasted with his geeky, normcore outfit. A pastel-pink blazer, aubergine slacks, a spotty tie and a blue-collar shirt completed the nerdy-but-nice ensemble. All pieces boasted a certain covertly fashionable chic, as they hailed from the House of Gucci. The normcore trend is perfect for Harry. Its celebration of unpretentious, unisex styling choices provides a sharp contrast with his more 'out-there' fashion statements: the brocade jackets and the glammed-up, glitterific jumpsuits. Sometimes you have to dress down in order to dress up.

OPPOSITE: *Harry Styles performs on NBC's* Today Show *at Rockefeller Plaza, New York City, NY, on 26 February 2020.*

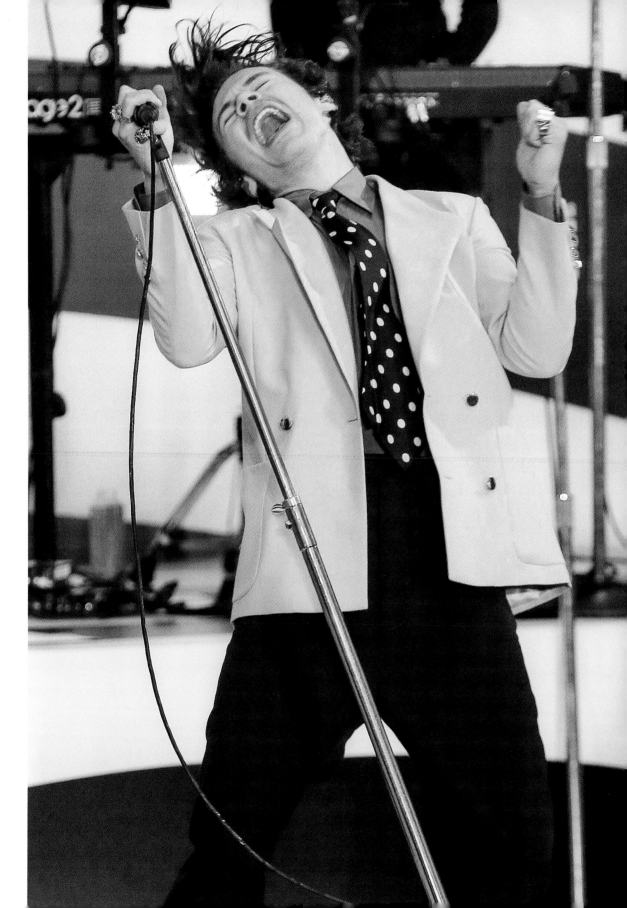

Think Tank

Harry's love of a sweater-vest is yet another example of his fearless fashion manoeuvres. A traditional top worn by cricketers to keep them warm when defending their wickets, tank-tops never hit the style headlines – not even in the '70s, when they twisted ever-so-slightly towards trendy. Donny Osmond, the teen-dream singer of the Mormon family pop group, was often papped wearing a woolly version, raising the heart palpitations of his pre-pubescent devotees. Harry's Lanvin blue-and-yellow spotty number, worn in 2020, raised the sweater-vest bar considerably – and, to some extent, opened the doors for the emergence of a Tank-Top Transformation Appreciation Society. Truly, sweater-vests have never looked so sexy.

THIS PAGE: *Donny Osmond at Heathrow Airport, having just arrived in England, 1972.*
OPPOSITE: *Harry Styles performs for SiriusXM and Pandora in the Music Hall of Williamsburg, New York City, NY, on 28 February 2020.*

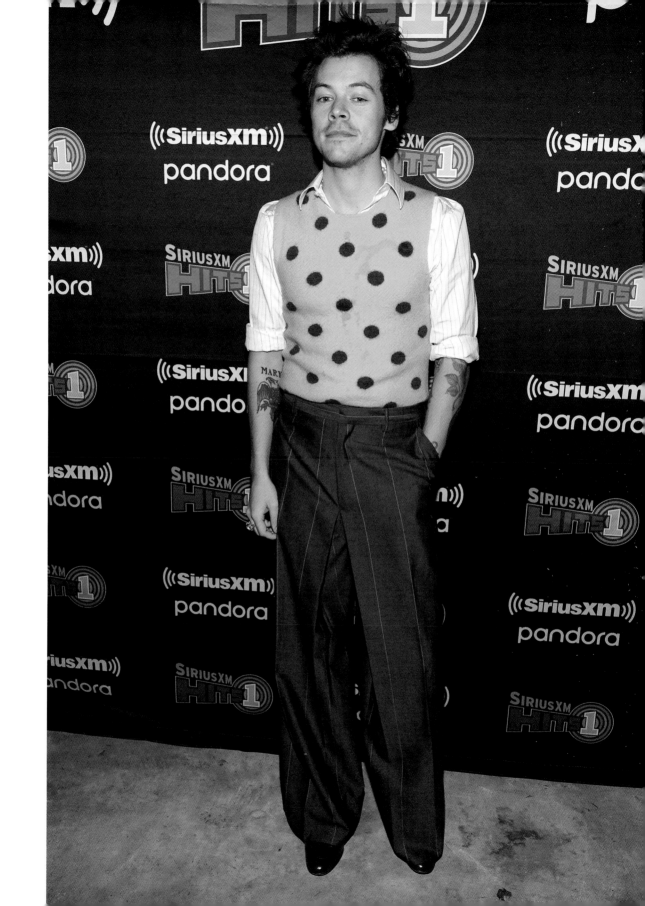

Animal Crackers

· ·

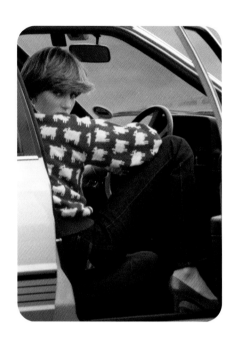

Lanvin's 'intarsia sheep' Spring/Summer 2020 tank-top, worn by Harry for a *Saturday Night Live* show rehearsal in NYC, took the nerd–slash–rock'n'roll–royal crossover look just one step further. Princess Diana is, of course, a certified style icon today – and for those who remain slightly bewildered by her edgy appeal, gaze at Harry's lamby look to observe exactly why conservative chic is such a winner. Cute and kooky, the contrast of conformist and rebel–without–a–cause has an undeniable charm.

' I don't think you should be scared
about embarrassing yourself;
I think it builds character ,
—Harry Styles, *Free Radio* interview, November 2014

THIS PAGE: *Lady Diana Spencer sits in her car during a polo match at Smith's Lawn, Windsor, London, June 1981. She wears a 'black sheep' wool jumper by Warm and Wonderful.*
OPPOSITE: *Harry Styles out and about in Manhattan, New York City, NY, on 12 November 2019.*

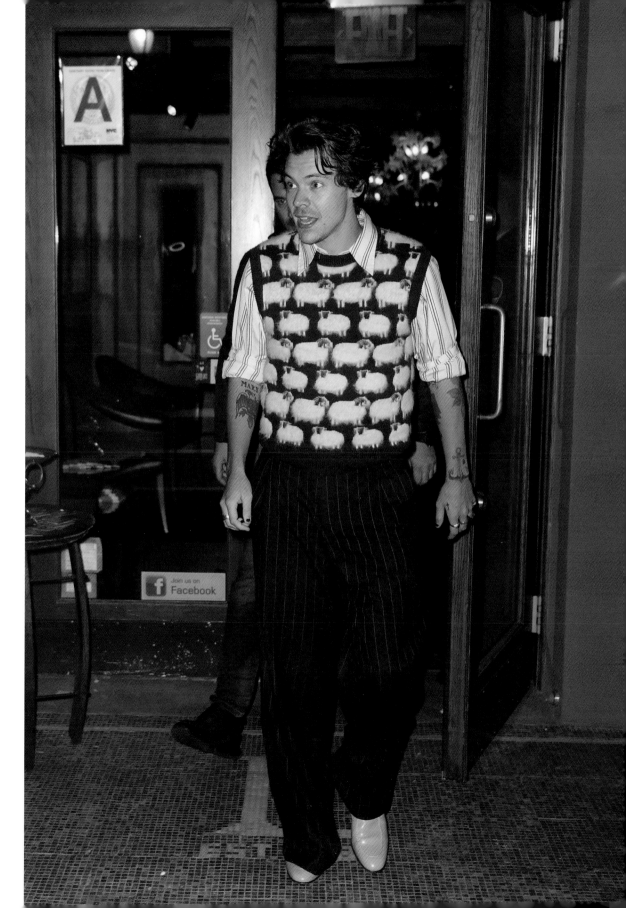

Show Off

· ·

'Cancelled due to Covid' was a common phrase in 2021. As a result, every single moment of happiness in the pandemic period seemed 100% more fun. When Harry announced that his 'Love on Tour' tour – postponed in 2020 – would set off in September 2021, fans were more than ready to dress up and dance with him again, and Styles took his costumes to another level in celebration. During the first gig, at the MGM Grand Garden Arena in Las Vegas, Styles sparkled in a custom pink Gucci sequin waistcoat that showed off his tattoos. It was all any superfan had dared dream of during lockdown – and, as usual, Harry delivered a heartfelt performance, at one point skipping across the stage with a rainbow pride flag to show his love. Finished off with flapping palazzo pants, cream patent boots and tassels galore, this outfit effortlessly rolled rock and glam into one.

OPPOSITE: *Harry Styles performs onstage during the tour opener for Love On Tour at MGM Grand Garden Arena on 4 September 2021 in Las Vegas, NV.*

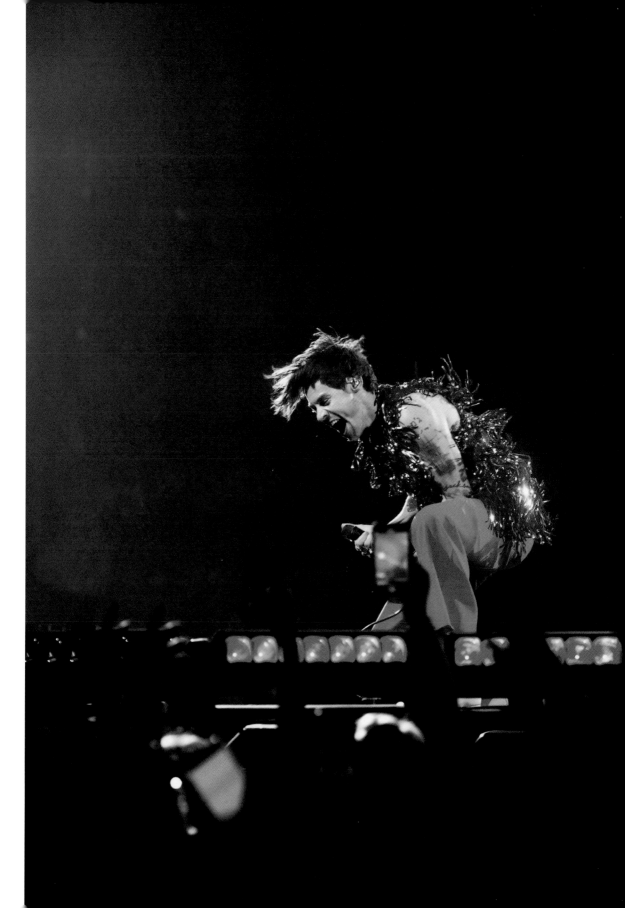

Harryween

· ·

Halloween in NYC is often a spooktacular experience, but at his Madison Square Garden concert in October 2021, Styles went for sublime over scary: dressed as Dorothy from *The Wizard of Oz*, in Alessandro Michele's interpretation of the famous blue gingham frock. Accessorised with a pair of ruby-red Gucci slippers, trompe l'oeil ankle-socks and a basket complete with a stuffed 'Toto' puppy, the ensemble paid scrupulous attention to movie-magic detail. Harry's lace-trimmed bloomers were an exquisite added touch, and his rendition of 'Somewhere over the Rainbow' hit all the right notes. The glamour of Golden-Era Hollywood went on to inspire Michele's 'Love Parade' 100 Gucci collection, shown in LA in November 2021 – and harmonising perfectly with Styles' charming Halloween homage to this beloved 1939 fantasy film.

'A heart is not judged by how much you love;
but by how much you are loved by others '
—*The Wizard of Oz, by Frank Baum.*

OPPOSITE: *Harry Styles performs onstage at the 'Harryween' Fancy Dress Party at Madison Square Garden, New York City, NY, on 30 October 2021.*

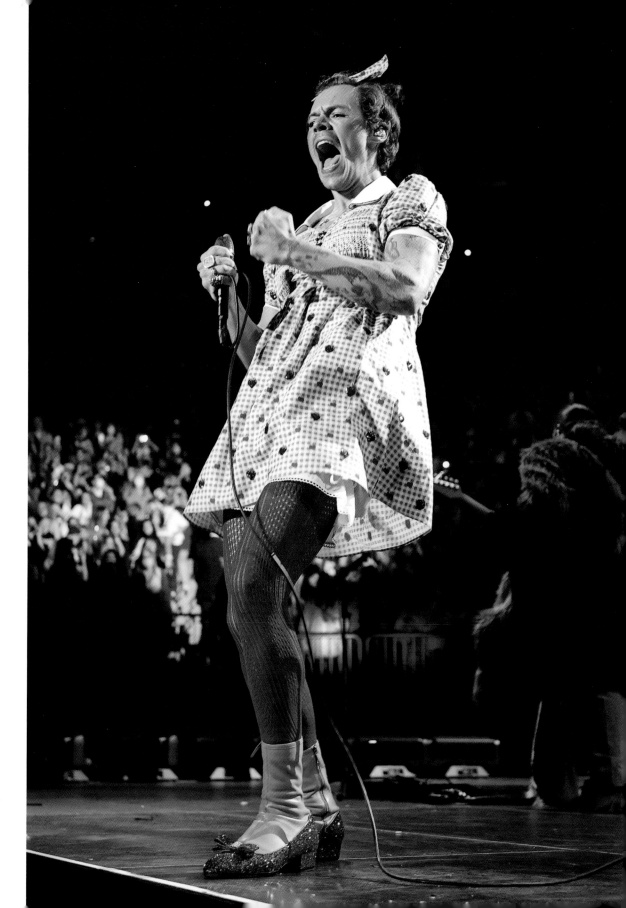

These Foolish Things

Pierrot, a character from the commedia dell'arte – a late–16th–century Italian troop of entertainers – inspired Gucci's second look for Styles at the 'Harryween' Love on Tour night at Madison Square Gardens on 31 October 2021. It was quite the call–back; the aristocratic bright young things of 1920s London would don such disguises before they partied and shrieked across the city at night. Gucci's take was suitably grand, featuring an extravagantly ruffled Elizabethan cream–cuffed blouse embellished with black stars and moon decorations, matched with very contemporary studded white booties. Styles shone bright as ever that night, surrounded by his tribe of fabulous fans. Harry had invited them to join him at the witching hour in their own best outfits – and they stepped up to clown around in finery.

OPPOSITE: *The next night, on 31 October 2021, Harry Styles completes his 'Harryween' Fancy Dress Party performances at Madison Square Garden, New York City, NY.*

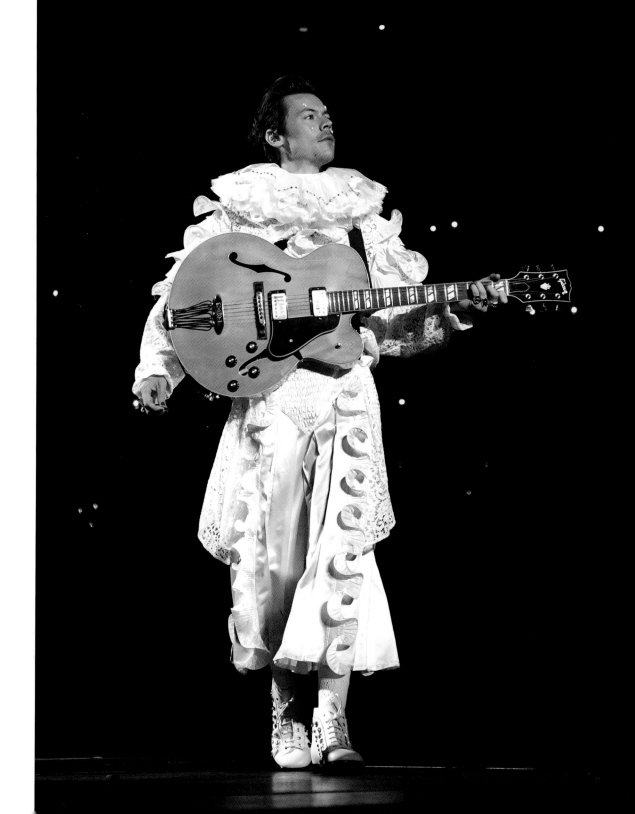

Baby-Face

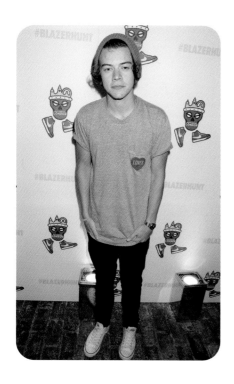

Harry's fashion styling has undergone a dramatic evolution. From a super-sweet 16-year-old nerdy skate boy wearing beanies and Vans, to a nerdy rock'n'roll star in tank-tops and '70s slacks, Harry has owned his credibility for over 10 years, and has always worn his heart on his sleeve. Looking back on his love of vintage T-shirts, band merch and classic black jeans to where he is now – an expert connoisseurship of cool – his wardrobe presents a clear progression of advancing sartorial discovery. Where will Harry go next? One fact is certain: though impossible to predict, it'll sure be fun to watch.

THIS PAGE: *Harry Styles attends Tinie Tempah's Disturbing London x Nike Blazer launch at Shoreditch House, London, UK, on 5 July 2012.*
OPPOSITE: *Harry Styles performs with a puppy from the Delco SPCA at Radio Station Q102 iHeartRadio Performance Theater in Bala Cynwyd, PA, 17 March 2012.*

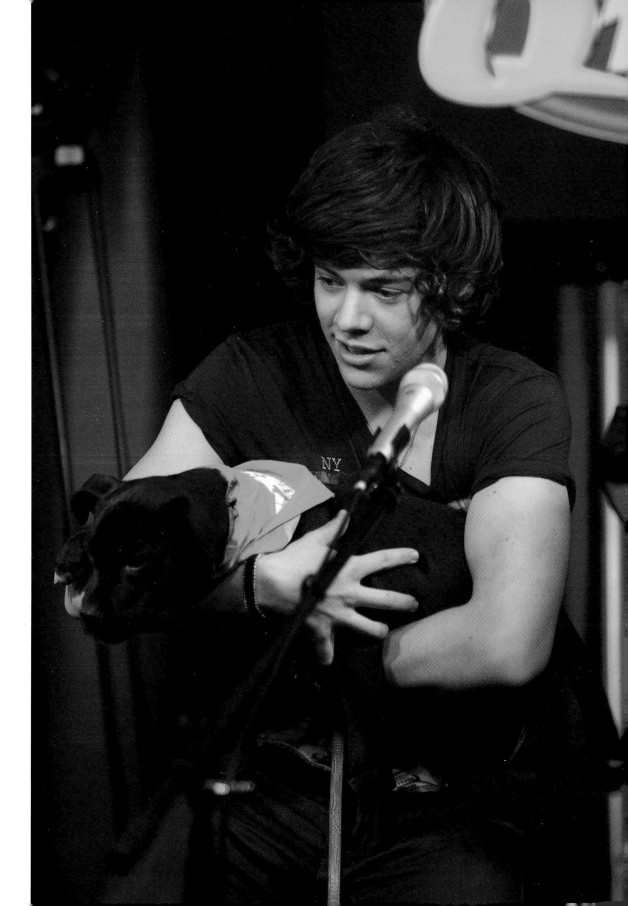

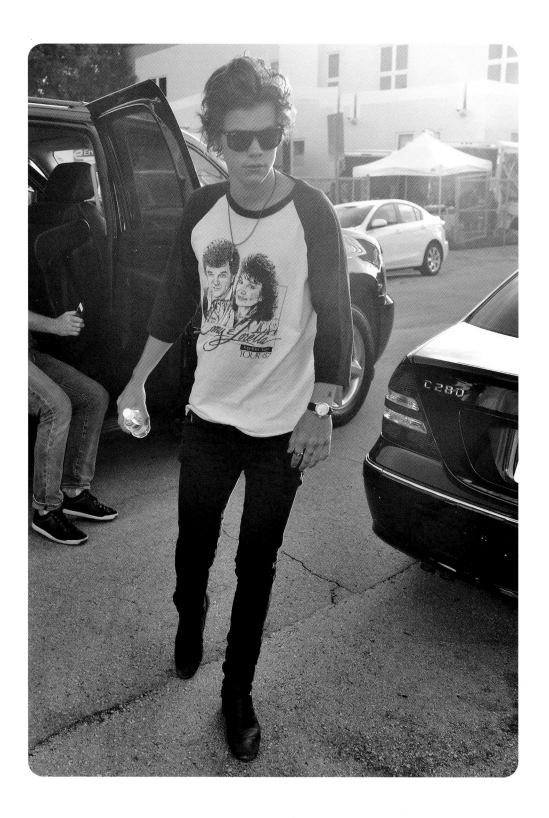

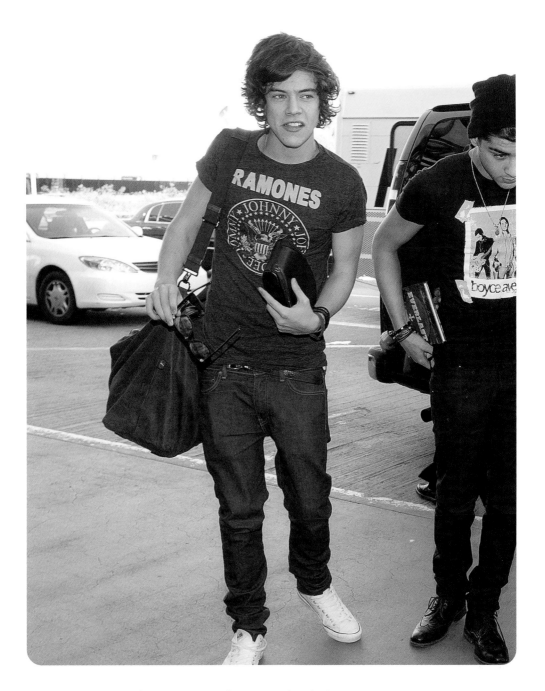

THIS PAGE: *Harry Styles at Los Angeles International Airport on 1 February 2012.*

OPPOSITE: *Harry Styles arrives at Temple House in Miami Beach, FL, on 12 June 2013.*

Image Credits

COVER: Anthony Pham via Getty Images
p.2 Jeff Kravitz / Film Magic, Inc via Getty Images
p.10 TOP P. Felix / Hulton Archive via Getty Images
p.10 MIDDLE United Archives GmBH / Alamy Stock Photo
p.10 BOTTOM Michael Ochs Archives via Getty Images
p.11 Anthony Pham / Getty Images Entertainment via Getty Images
p.12 Robert Gauthier / Los Angeles Times via Getty Images
p.13 Amy Sussman / Getty Images Entertainment via Getty Images
p.15 Kevin Winter / Getty Images Entertainment via Getty Images
p.17 Doug Peters / EMPICS / Alamy Stock Photo
p.20 Victor VIRGILE / Gamma-Rapho via Getty Images
p.21 Dave J Hogan / Getty Images entertainment via Getty Images
p.22 Terry O'Neill / Iconic Images
p.23 PA Images / Alamy Stock Photo
p.25 Handout / Helene Marie Pambrun via Getty Images
p.26 David Reed Archive / Alamy Stock Photo
p.27 Gonzales Photo / Alamy Stock Photo
p.29 JMEnternational / Getty Images Entertainment via Getty Images
p.30 TOP Anwar Hussein / Alamy Stock Photo
p.30 BOTTOM Mirrorpix / Mirrorpix via Getty Images
p.31 REUTERS / Alamy Stock Photo
p.32 LEFT Dia Dipasupil / Getty ImagesEntertainment via Getty Images
p.32 RIGHT PA Images / Alamy Stock Photo
p.33 Rich Fury / Getty Images Entertainment via Getty Images
p.34 Karwai Tang / WireImage via Getty Images
p.35 Terry O'Neill / Iconic Images
p.36 AF archive / Alamy Stock Photo
p.37 Ivan Nikolov / WENN Rights Ltd / Alamy Stock Photo
p.38 Storms Media Group / Alamy Stock Photo
p.41 SMXRF / Star Max / GC Images via Getty Images
p.42 Jeff Kravitz / FilmMagic, Inc via Getty Images
p.43 Helene Pambrun / Paris Match Archive via Getty Images
p.44 Independent Photo Agency Srl / Alamy Stock Photo
p.45 Chris Walter / WireImage via Getty Images
p.46 TOP Charlie Gillett Collection / Redferns via Getty Images
p.46 BOTTOM Dominique BERRETTY / Gamma-Rapho via Getty Images
p.47 WENN Rights Ltd / Alamy Stock Photo
p.50 David Cole / Alamy Stock Photo
p.51 John Palmer / Media Punch Inc. / Alamy Stock Photo
pp.52/53 Retro AdArchives / Alamy Stock Photo
p.54 PictureLux / The Hollywood Archive / Alamy Stock Photo
p.55 Kevin Mazur / AMA2014 / WireImage via Getty Images
p.57 Byron Purvis / AdMedia / Sipa USA / Alamy Stock Photo

p.58 TOP Barry King / Alamy Stock Photo
p.58 BOTTOM Art Zelin / Archive Photos via Getty Images
p.59 David M. Benett / Getty Images Entertainment via Getty Images
p.60 TOP Anne Fishbein / Michael Ochs Archives via Getty Images
p.60 BOTTOM JB Lacroix / WireImage via Getty Images
p.61 Rune Hellestad / Corbis Entertainment via Getty Images
p.62 Randy Pollick / AdMedia / Sipa USA / Alamy Stock Photo
p.63 Lasse Lagoni / Gonzales Photo / Alamy Stock Photo
p.65 C Flanigan / WireImage via Getty Images
p.66 TOP Michael Ochs Archives via Getty Images
p.66 BOTTOM Jason Merritt / Getty Entertainment via Getty Images
p.67 Anthony Harvey / Getty Entertainment via Getty Images
p.68 Laurent Viteur / WireImage via Getty Images
p.69 Terry O'Neill / Iconic Images
p.73 Karwai Tang / WireImage via Getty Images
p.74 EyeBrowz / Alamy Stock Photo
p.75 Pictorial Press Ltd / Alamy Stock Photo
p.76 Retro AdArchives / Alamy Stock Photo
p.77 Rw / Media Punch Inc. / Alamy Stock Photo
p.78 ScreenProd / Photononstop / Alamy Stock Photo
p.79 Photo by Sylvain Lefevre. Abaca Press / Alamy Stock Photo
p.81 Kevin Winter / Getty Images via Getty Images
p.82 Pictorial Press Ltd / Alamy Stock Photo
p.83 PA Images on behalf of So TV / Alamy Stock Photo
p.85 Emma McIntyre / Getty Images Entertainment via Getty Images
p.87 Emma McIntyre / Getty Images Entertainment via Getty Images
p.88 Baron Wolman / Iconic Images
p.89 GORC / GC Images via Getty Images
p.90 Matt Crossick / Empics /Alamy Stock Photo
p.91 Ross Marino / Icon and Image / Michael Ochs Archives via Getty Images
p.92 TOP Michael Putland / Hulton Archive via Getty Images
p.92 BOTTOM Trinity Mirror / Mirrorpix / Alamy Stock Photo
p.93 Doug Peters / Alamy Stock Photos
p.95 David M. Benett / Getty Images Entertainment via Getty Images
p.97 Terence Patrick / CBS Photo Archive via Getty Images
p.99 David M. Benett / Getty Images Entertainment via Getty Images
p.100 TOP Pictorial Press Ltd / Alamy Stock Photo
p.100 BOTTOM Ross Marino / Icon and Image / Michael Ochs Archives via Getty Images
p.101 Kevin Mazur / Getty Images Entertainment via Getty Images
p.102 Ross Marino / Icon and Image / Michael Ochs Archives via Getty Images
p.103 James D. Morgan / WireImage via Getty Images

p.104 Pictorial Press Ltd / Alamy Stock Photo
p.105 PA Images / Alamy Stock Photo
p.107 Terence Patrick / CBS Photo Archive via Getty Images
p.109 Neil Mockford / GC Images via Getty Images
p.110 Terry O'Neill / Iconic Images
p.111 Kevin Mazur / Getty Images Entertainment via Getty Images
p.112 TOP Michael Putland / Hulton Archive via Getty Images
p.112 BOTTOM TheCoverVersion / Alamy Stock Photo
p.113 C Flanigan / Getty Images Entgertainment via Getty Images
p.114 C Flanigan / FilmMagic via Getty Images
p.115 Steve Jennings / Getty Images Entertainment via Getty Images
p.116 Retro AdArchives / Alamy Stock Photo
p.117 Retro AdArchives / Alamy Stock Photo
pp.118/119 Retro AdArchives / Alamy Stock Photo
p.120 Janet Macoska / Iconic Images
p.121 Rich Fury / Getty Images Entertainment via Getty Images
p.123 Marc Piasecki / GC Images via Getty Images
p.124 Blueee / Alamy Stock Photo
p.125 WENN Rights Ltd / Alamy Stock Photo
p.127 JB Lacroix / WireImage via Getty Images
p.128 Bettmann via Getty Images
p.129 WENN Rights Ltd / Alamy Stock Photo
p.130 Estrop / Getty Images Entertainment via Getty Images
p.131 INSTAR Images LLC / Alamy Stock Photo
p.134 TOP RTSpellman / MediaPunch Inc. / Alamy Stock Photo
p.134 BOTTOM Everett Collection Inc / Alamy Stock Photo
p.135 PA Images / Alamy Stock Photos
p.136 Steve Parke / Iconic Images
p.137 John Angelillo / UPI / Alamy Stock Photo
p.139 Christie Goodwin / Redferns via Getty Images
p.141 Image Press Agency / Alamy Stock Photo
p.142 Hulton-Deutsch / Corbis Historical via Getty Images
p.143 Kevin Mazur / Getty Images Entertainment via Getty Images
p.144 Bob Thomas / Popperfoto via Getty Images
p.145 Robert Kamau / GC Images via Getty Images
p.147 Anthony Pham / Getty Images Entertainment via Getty Images
p.149 Theo Wargo / Getty Images Entertainment via Getty Images
p.151 Kevin Mazur / Getty Images Entertainment via Getty Images
p.152 Dave M. Benett / Getty Images Entertainment via Getty Images
p.153 Bill McCay / WireImage via Getty Images
p.154 Olivia Salazar / WireImage via Getty Images
p.155 GVK / Bauer-Griffin / GC Images via Getty Images

References

https://www.vogue.co.uk/article/harry-styles-met-gala-outfit-details

https://theface.com/music/harry-styles-feature-interview-music-stevie-nicks-elton-john-alessandro-michele-volume-4-issue-001

https://www.vogue.com/article/harry-styles-cover-december-2020

https://wwd.com/fashion-news/fashion-features/fashion-gender-fluid-trend-schools-stores-1234650024/

https://www.theguardian.com/music/2019/dec/14/harry-styles-sexual-ambiguity-dating-normals-rocking-a-dress

https://www.lofficielusa.com/gucci-beauty/harry-styles-fine-line-gucci-cover-story

https://www.rollingstone.com/music/music-features/harry-styles-favorite-things-albums-tv-878041/

https://www.esquire.com/uk/style/a30418462/elvis-presley-style/

https://www.rockhall.com/rock-roll-hall-fame-adds-harry-styles-suit-right-here-right-now-exhibit

https://wwd.com/eye/lifestyle/hedi-times-3557151/

https://www.vogue.com/fashion-shows/fall-2015-menswear/saint-laurent

https://www.oocities.org/heartland/hills/5581/melb66.htm

https://coveteur.com/2021/01/19/harry-lambert-interview/

https://www.voguebusiness.com/companies/how-jw-anderson-harry-styles-cardigan-went-viral-on-tiktok

https://www.jwanderson.com/gb/cardigan-pattern

https://harryfashionarchive.com/post/650989217999192064/harry-at-the-grammys-brits-marchmay-2021

https://fidmmuseum.org/2018/09/geoffrey-beene.html – Geoffrey Beene, Grace Mirabella: Unbound, *Museum at the Fashion Institute of Technology*, 1994.

https://fidmmuseum.org/2018/09/geoffrey-beene.html

https://www.youtube.com/watch?v=TggVF2YixAs Audacy Radio Music podcast, 6 December, 2019

https://www.youtube.com/watch?v=wUfElcG0LNs Met Gala with Liza Koshy red carpet interview, 7 May 2019

https://vman.com/article/the-pink-rethink/The Pink Rethink, *VMagazine,* Dylan Gray Martin, online, 5 November 2018

https://www.rollingstone.com/feature/harry-styles-new-direction-119432/ Cameron Crowe, 'Harry Styles' New Direction', *Rolling Stone,* 18 April 2017

https://www.youtube.com/watch?v=zB8l9kAVqV4 Grazia '2 pairs of jeans' 2013 British Fashion Awards red carpet video.

https://audioboom.com/posts/2616391-when-free-radio-met-one-direction#t=2m29s Free Radio Interview, 3 November 2014

https://www.youtube.com/watch?v=Rg-Y1LSsJNk Harry Styles on Howard Stern Show, 4 March 2020

https://www.youtube.com/watch?v=plHE9ly5T5U Hits Radio interview, 31 October 2019

Acknowledgements

Many thanks to Carrie Kania and Eleanor Rachel at Iconic Images, as well as to James Smith, Bryn Porter, Susannah Hecht, Craig Holden, Corban Wilkin, Dan Pattinson and all at ACC Art Books. Also, to Andrew, Freddie, William and Chop Newman, Mick Rooney, Gina Gibbons, Pippa Healy, Michael Costiff and Jo Unwin, for their love and encouragement.

Biography

Terry Newman is a fashion historian who worked in industry for over 15 years as a journalist and stylist and now writes about fashion, art, and culture. Recent books include *Legendary Authors and the Clothes they Wore* and *Legendary Artists and the Clothes they Wore*. During the 1990s, she was employed as Shopping Editor at *i–D* magazine, Associate Editor at *Self Service*, Consumer Editor at *Attitude*, and as a TV presenter for Channel 4 fashion programmes *She's Gotta Have it* and *Slave*. Her journalism has been published in *The Guardian*, *The Times* and *The Sunday Times*, *Time–Out*, *The Big Issue*, *The Independent*, *Viewpoint* among others and she contributed to *i–D's Fashion Now*, *Fashion Now2*, and *Soul i–D books*. Newman currently lectures at The University for the Creative Arts, Regents University, and The University of West England. She lives in London with her husband, two sons and an English Bulldog.

' I'm really surprised
[to be nominated as a style icon];
I've only got
two pairs of jeans. '
Harry Styles, *The British Fashion Awards 2013.*

ISBN: 978-178884-170-2

First published by ACC Art Books in 2022
Fourth printing 2022

British Library Cataloguing-in-Publication Data
A catalogue record for this book is available from the British Library

The author and publisher gratefully acknowledge the permission granted to reproduce the copyright material in this book.
Every effort has been made to trace copyright holders and to obtain their permission for the use of copyright material. The
publisher apologises for any errors or omissions in the text and would be grateful if notified of any corrections that should
be incorporated in future reprints or editions of this book.

Cover: Harry Styles poses for the 2021 GRAMMY Awards on 14 March 2021 in Los Angeles, CA
Frontispiece: Harry Styles performs onstage at The Greek Theatre on 20 September 2017 in Los Angeles, CA

Printed in Slovenia
for ACC Art Books Ltd., Woodbridge, Suffolk, England

www.accartbooks.com

ACC
ART
BOOKS